IMAGES
of America

AVONDALE AND
CHICAGO'S POLISH VILLAGE

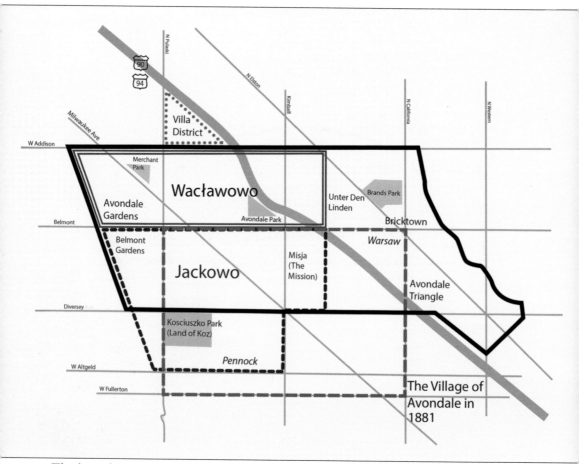

The boundaries of Avondale and Chicago's Polish Village are somewhat fluid. The area of strongest Polish settlement was west of Kedzie Avenue, along the Milwaukee Avenue Corridor in Jackowo and Wacławowo, as shown on the map. Additionally, these twin "Polish patches" and the larger "Polish Village" that they collectively comprise extended outside the boundaries of the Avondale Community Area. Among those outside of the Avondale area's bounds are the Kościuszko Park neighborhood (lower left), also known as "The Land of Koz," and the Villa District (upper left), which Mike Royko christened "Polish Kenilworth." (Courtesy Martha Iserman.)

ON THE COVER: Though Avondale and Chicago's Polish Village are pigeonholed as a landscape of smokestacks and steeples, the Olson Waterfall was the local landmark familiar to Chicagoans citywide before its demolition in the 1970s. Playfully dubbed "the Bohemian Dells," this private park built adjacent to the former Olson Rug Factory at Diversey Avenue and Pulaski Road regularly drew crowds of working-class families picnicking and relaxing on daylong trips. With so much nostalgia surrounding the site, there is little wonder as to why the Olson Waterfall topped the list of "Chicago's Seven Lost Wonders" compiled by the Chicago Tribune. (Courtesy Chicago Transit Authority.)

IMAGES
of America

AVONDALE AND
CHICAGO'S POLISH VILLAGE

Jacob Kaplan, Daniel Pogorzelski,
Rob Reid, and Elisa Addlesperger
with a Foreword by Dominic Pacyga

ARCADIA
PUBLISHING

Published by Arcadia Publishing
Charleston, South Carolina

Printed in the United States of America

Library of Congress Control Number: 2013941161

For all general information, please contact Arcadia Publishing:
Telephone 843-853-2070
Fax 843-853-0044
E-mail sales@arcadiapublishing.com
For customer service and orders:
Toll-Free 1-888-313-2665

Visit us on the Internet at www.arcadiapublishing.com

This book is dedicated to Joseph Jurek. A firm believer in public service, Joseph has done volunteer work for religious, medical, athletic, and community organizations. He has been recognized many times for his dedication, and he continues his activism into the present day by leading the Parish Council at St. Hyacinth Basilica in Avondale.

CONTENTS

FOREWORD

Chicago has long been a welcoming home to immigrants from around the world. By 1910, immigrants and their children made up nearly 80 percent of the city's population. Poles in particular flocked to the city in the years between the American Civil War and World War I, making Chicago the capital of America's Polonia. They settled across the city, but particularly in the Milwaukee Avenue corridor, which made its way from Polish Downtown to the then distant northwest suburbs. Beginning near the intersection of Milwaukee and Ashland Avenues, a series of Polish Catholic and Polish National Catholic parishes as well as the major Polish fraternal organizations were established, providing a solid base for the Chicago Polish community.

Avondale, a manufacturing neighborhood of modest working-class homes, soon attracted many Polish Americans as they made their way "up" Milwaukee Avenue. By World War I, the district attracted a considerable Polish population that lived and labored among Germans, Jews, Irish, and other white ethnics who also called Avondale and the surrounding neighborhoods home. Large Polish Catholic parishes such as St. Hyacinth and St. Wenceslaus have continuously provided an institutional base for the Avondale community. From the 1970s through the 1980s, the neighborhood attracted Polish immigrants fleeing the tribulations their homeland confronted as Poland was reborn in the wake of the Soviet Union's collapse. The area provided material support for the homeland the immigrants left behind. Over the years, other Poles who pursued economic opportunities in Chicago have joined the "Solidarity" wave of immigrants to Avondale.

Currently, additional groups have made their way up Milwaukee Avenue to Avondale, including Hispanics, other recent European immigrants, and "Yuppies" who have brought some gentrification to the area as industry has left the district. Despite ethnic and economic change, this neighborhood remains an important Polish American settlement and is often referred to by Chicagoans as the "Polish Village." While the majority of Polish Americans have made their way to the suburbs, Avondale retains its Polish flavor, and the area continues to play an important role in the life of the city of Chicago.

—Dominic A. Pacyga, PhD
Columbia College/Chicago

INTRODUCTION

First came the Indians, then the explorers, and lastly the fur-trappers and frontiersmen. The receding waters of glacial Lake Chicago, the predecessor of today's Lake Michigan, had left the landscape flat and the soils of today's Avondale marshy and damp in its wake. While this wet soil would prove to be a serious problem for the farmers who later settled here, it was a boon for those traveling through the area. Water is one of the oldest ways to travel over long distances, and most ancient settlements were built near it to facilitate communication with the outside world, a notion that even the Romans kept in mind as they assembled their vast empire. This water gave life to Chicago, sandwiched between the Great Lakes and the reach of rivers bound for the Mississippi and the warm shores of the Gulf of Mexico. Only its strategic value could overcome the inhospitable nature of this terrain, the last part of Illinois to be settled. The revolutionary canal that Joliet and Marquette imagined in their 17th-century travels would take more than 100 years to materialize.

However long it took and however costly its construction, the canal was finally built, and the city was born. Chicago burst forth with a bang, and people of all walks of life and from every corner of the world ventured here to try to strike it rich, as they still do. Industry boomed, and people would follow the herds of cattle bound for the stockyards. The city's population was already 110,000 on the eve of the Civil War, a far cry from the 4,000 when it was chartered in 1837. In the span of just 10 years, between 1880 and 1890, the population doubled, from 500,000 to over a million citizens. Expansion became inevitable, and Jefferson Township, a quiet setting for truck farmers, was one of many areas Chicago annexed in 1889. This township was a wide expanse, bordered by present-day North Avenue to the south and Devon Avenue to the north and by Western Avenue to the east and Harlem Avenue to the west. Consisting mostly of open plains, Jefferson Township included a small hamlet that was commonly referred to as "Avondale," now firmly within the city limits of Chicago.

What began as prairie is now an intrinsic part of the residential fabric of Chicago. While Avondale is often synonymous with the Polish community, thanks to the prominence of Chicago's Polish Village, this truth is certainly more complicated than it initially seems. None of Chicago's ethnic enclaves, such as Pilsen, Greektown, Little Italy, Paseo Boricua, or countless other cultural districts, have been devoid of other peoples, and Avondale and Chicago's Polish Village are no different. Yankee, German, Swedish, and even African American patches were an intrinsic part of the social environment of Avondale from the very beginning. While this cultural kaleidoscope has shifted over time with the addition of the Irish, Jews, Norwegians, Italians, Filipinos, Latinos, and peoples from all over the former Soviet Bloc, Polish culture still thrives here. Institutions such as Polvision and Polish Radio 1030 keep Poles all over Chicago informed on the latest goings-on, both in Chicago and Poland. Polish businesses provide customers with ethnic wares, while Polish bars, clubs, and restaurants keep their clients entertained and well fed. St. Hyacinth Basilica and St. Wenceslaus serve as both social centers and spiritual hubs for Poles all over Chicagoland.

While the heart of Polish Chicago certainly beats in Avondale, other voices are an essential part of the neighborhood's story.

Befitting the Shakespearean origin of its name (William Shakespeare was born in Stratford-upon-Avon), the boundaries of Avondale and Chicago's Polish Village are somewhat fluid. With the "Village of Avondale" extending as far south as Fullerton Avenue between Pulaski Road and California Avenue in 1881, Avondale predates its more recognized sister neighborhood of Logan Square to the south, giving rise to all sorts of curiosities when comparing the early history of both communities. While Poles could be found in all corners of Avondale, the area where Polish settlement was most visible was west of Kedzie Avenue along the Milwaukee Avenue corridor in Jackowo and Wacławowo. Additionally, these twin "Polish patches" and the larger Polish Village, or "Polska Osada," that they collectively comprise, extended well outside the boundaries of the Avondale Community Area. The Kościuszko Park neighborhood in the area of Logan Square, as well as the Villa District (Polskie Wille) and Merchant Park neighborhood in the Irving Park Community Area, has historically been vital parts of the Polish Village outside of the Avondale Community Area's bounds. Finally, nascent gentrification and the trendier name recognition of bordering districts have led to a quirky partition of Avondale into an array of imaginary neighborhoods, such as West Roscoe Village and South Old Irving, as well as both North and West Logan Square.

What lends Avondale and Chicago's Polish Village unity, however, is the proletarian nature of its built environment. Known as "the neighborhood that built Chicago," the brick pits in Avondale's Bricktown that once lined Belmont Avenue were used to build a city that was bursting at the seams. Many of Avondale's residents worked in the factory buildings that still make up an integral part of the local landscape, with their smokestacks vying for the skyline with the majestic steeples of the area's many churches. It was this grit that has long captivated the attention of outsiders, such as street photographer Vivian Maier, who came to Avondale to capture that spirit in her lens.

Today, Avondale and Chicago's Polish Village are experiencing a renaissance, with renewed interest in the area powered by its geography as well as an outpouring of creative zeal. Festivals such as the A Day in Avondale art walk, the Rafael López Mural and Garden, the new plaza at Woodard Street, and local arts initiatives spanning continents—such as Voice of the City's recent collaboration with Teatr Brama Goleniów, the opening of the Puerto Rican Arts Alliance, and the Holiday Concert of Golec uOrkiestra at St. Hyacinth Basilica—all show the power that art has, not only in bringing people together but also in serving as an economic engine. Highlighting this point, artist Piotr Wolodkowicz, in conjunction with the Greater Avondale Chamber of Commerce, designed a historic crest for Chicago's Polish Village and is working towards getting it endorsed by the government of Poland. Coupled with the recent rezoning of Milwaukee Avenue between Kimball and Central Park Avenues as artist-friendly live-work space, Avondale is once again reinventing itself. Nonetheless, locals pride themselves, in whatever language they may speak, that Avondale is without a doubt "True Chicago."

As this book is a collection of vintage photographs, there are many remarkable places and curiosities in Avondale and Chicago's Polish Village that are not featured here. Nonetheless, we hope you enjoy our humble attempt to bring you the history of this proletarian nook of Chicago.

One

BEGINNINGS

Avondale's first inhabitants were Native American tribes. Records exist of the Chippewa, Ottawa, Pottawatomi, and Kickapoo Indians in the area, although it is known that many other groups stayed here for a time, only to set off for new sites during their nomadic travels across the North American continent. The land that would become Avondale differed little from its surroundings, with isolated clumps of trees like islands in a monotonous sea of grasslands.

This quiet prairie area surrounding Chicago was incorporated as Jefferson Township in 1850. Following an old Native American trail, two new thoroughfares were created at roughly the same time. Referred to as the Upper and Lower Northwest Plank Roads, these routes were traversed largely by truck farmers en route to sell their goods at the Randolph Street Market. Known today as Milwaukee and Elston Avenues, these two diagonal thoroughfares break up the monotony of the city's ever-present grid.

Historical information regarding the beginnings of Avondale is murky and occasionally contradictory, making it difficult to sort out the true course of events. Nonetheless, there is undoubtedly an interesting array of characters involved in forming this rural hamlet. Among them are Scotsman Alexander Brand and Albert Wisner, a Yankee of Swiss heritage. Their subdivisions still bear their names to the present day. The 1870s witnessed a flurry of building activity in the area, with developers Brian Philpot and John L. Cochran both credited with having christened the area Avondale. During this same time, Michigan senator Thomas White Ferry, familiar with northern Illinois from his youth, invested in the area and likely used his influence to assure that the proper infrastructure was built to service the nascent village. Rev. John B. Dawson created a haven for African American freedmen, who had the area's first known house of worship, which lasted until Dawson's descendants left for Bronzeville on Chicago's South Side.

Although settlement in the area began with the extension of the Chicago, Milwaukee, St. Paul & Pacific tracks to Milwaukee in 1870 and the building of a post office at the corner of Belmont Avenue and Troy Street at a stop of the Chicago & North Western Railway in 1873, real development would wait until after Jefferson Township was annexed to the city after 1889. As the city improved local infrastructure, the plank roads gave way to pavement and streetcar lines, corridors by which individuals would pour in from the city's overpopulated core.

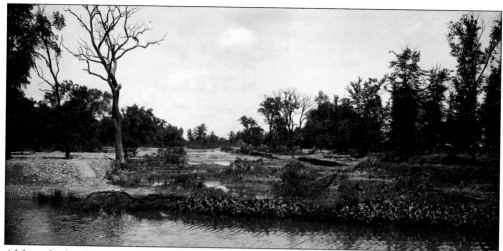

Although the first recorded land purchase in what would become Avondale dates to 1838, settlement in the area was sparse before annexation to Chicago in 1889. In 1881, the village of Avondale had a population of roughly 250 residents living in 60 homes, within the area now bounded by Belmont Avenue to the north, Fullerton Avenue to the south, California Avenue to the east, and Pulaski Road to the west. This photograph, taken between Addison Street and Belmont Avenue in 1904 by the Metropolitan Sanitary District, shows just how undeveloped parts of Avondale were at the time. (Courtesy Illinois State Archives.)

The former town hall for the village of Maplewood is seen here in 1914. The village was founded in 1869 on land purchased by Commissioner Justin Butterfield (1790–1855) twenty-six years earlier. Judging from this photograph, the building was put to good use as a saloon after annexation to the City of Chicago made its original function obsolete. This structure was located at the northeast corner of Diversey and Washtenaw Avenues, adjacent to the now-closed Maplewood station on the Chicago & North Western Railway (C&NW). The building's location is now directly underneath the Kennedy Expressway. (Courtesy Chicago History Museum, ICHi-18494.)

Sen. Thomas White Ferry played a key role in the beginnings of Avondale. The building of a brick rail station along the C&NW tracks as well as the opening of an adjacent Avondale post office are both attributed to him. This assertion makes sense; Senator Ferry served as chairman of the Committee on Post Office and Post Roads between 1877 and 1879 and again between 1881 and 1883. Given that the senator's realty firm, Ferry and Bros., built a nearby subdivision of 12 homes in 1875, he certainly had good reason to push for it. (Courtesy Library of Congress, Brady-Handy Collection, LC-DIG-cwpbh-04205.)

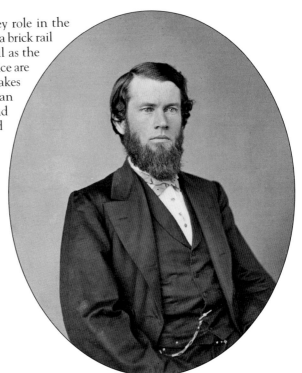

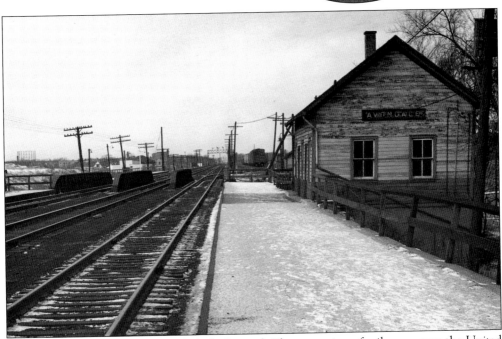

Avondale's growth was inextricably linked to rail. The expansion of railways across the United States, with Chicago at its center, enabled the city to develop as a thriving hub of industry and manufacturing. This in turn spurred numerous immigrants to settle here in the pursuit of work. This 1958 photograph shows the Avondale station, built in 1908 as part of the elevation of the C&NW. (Photograph by John McCarthy, courtesy Chicago History Museum, ICHi-22682.)

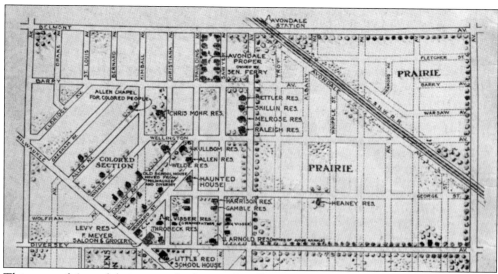

This map of Avondale is part of a larger plat illustrating what would become the Chicago community areas of Avondale and Logan Square. The map depicts the areas as they appeared in 1881, according to the recollections of A. Stehmann, who was the longtime principal of Avondale Elementary School. Note that Warsaw Avenue had not yet been changed to its current name, Nelson Avenue. (Courtesy Avondale School.)

John B. Dawson, a minister in the African Methodist Episcopal Church, purchased a large tract of land in Jefferson Township in the years immediately following the Civil War. There, he established the AME Allen Chapel of Avondale, which fostered a growing community of African American parishioners. The "Allen Church," as it is popularly referred to, was located on Allen Street north of Milwaukee Avenue and west of Kimball Avenue. By the turn of the 20th century, Rev. Dawson's descendants and parishioners had started to disperse to Bronzeville on the South Side, which became the cultural capital of African American Chicago. (Courtesy Annaya London.)

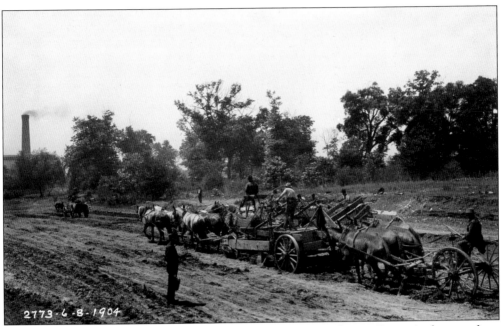

This photograph looks south from Addison Street along the Chicago River. A chimney from the Chicago Railways Company powerhouse disrupts this rustic scene. It was the expansion of the streetcar network after annexation that rapidly put an end to the rural era in this and many other Chicago neighborhoods. (Courtesy Illinois State Archives.)

The area along Wrightwood Avenue just east of Pulaski Road was a stillborn development by mining entrepreneur Homer Pennock. He spared no effort to grow his factory town, fortuitously located next to the Milwaukee Railroad, but unfortunately a string of setbacks thwarted his plans. A 1903 *Chicago Tribune* article titled "A Deserted Village in Chicago" described Pennock's industrial ruins, complete with photographs of the derelict structures. While Homer Pennock's industrial suburb failed, Chicago's rapid expansion transformed the local farms into clusters of factories and homes, as can be seen in this photograph of Monticello Avenue, looking north of Wrightwood Avenue, which was originally laid out as Pennock Boulevard. (Courtesy Michael Jaskula.)

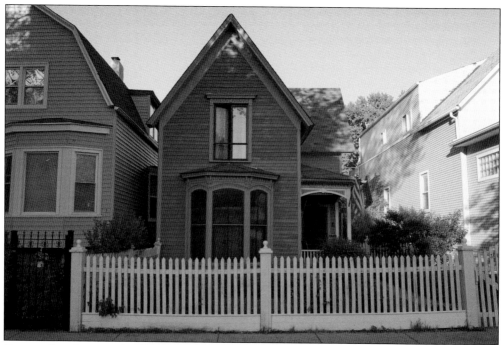

Senator Ferry's original subdivision from 1875 consisted of 12 homes in the block bounded by Belmont Avenue to the north, Barry Avenue to the south, Spaulding Avenue to the west, and Sawyer Avenue to the east. A number of the structures, such as this one at 3119 North Spaulding Avenue, have survived to the present day. Although identified as architecturally significant by the Chicago Historic Resources Survey, none are protected by official landmark status, making them vulnerable to demolition at any time. (Courtesy Jacob Kaplan.)

Another remnant of Avondale's bygone rural era was this 1880s barn, located in the alley behind 2934 North Wisner Avenue. The avenue gets its name from Albert Wisner, a Yankee businessman of Swiss heritage who grew wealthy in his commercial dealings after relocating to Chicago. This section of Avondale, where the grid shifts directly perpendicular to Milwaukee Avenue, is known as "Wisner's Subdivision," which is Wisner's contribution to Avondale's geography. The barn was recently demolished. (Courtesy Gabriel X. Michael.)

Two

THE NEIGHBORHOOD
THAT BUILT CHICAGO

Avondale is historically a working-class community of factories, where generations of workers toiled to create products that were sold and shipped around the globe. Early Avondale grew up around the railroad, and factories and industries tended to follow these railroad corridors. Henry Frerk's lumber business, one of the first industries in the area, was located along the Chicago & North Western Railway and provided lumber for a growing community. New homes were built to house factory workers, mostly modest edifices of frame and simple brick construction, with a few exceptions. Germans, Scandinavians, Poles, and others began to move into the community to take advantage of new jobs.

The Chicago River influenced the development of eastern Avondale. Channelized soon after the turn of the 20th century, the river's banks saw much of Avondale's heavy industry spring up, including power plants, tanneries, and boat yards. The community continued to grow.

As Avondale matured in the mid-20th century, manufacturing of all types continued to expand and locate in the area. Whether it was the largest commercial lithographing company in the world, the brewer of a famous brand of root beer, a manufacturer of pinball machines, or a maker of ventilating fans, Avondale seemingly made everything under the sun, and the area employed thousands in the industrial sector. But massive changes in manufacturing trends greatly affected Avondale beginning in the 1970s. Layoffs commenced, and longtime manufacturers began to close. Avondale began a period of relative decline, similar to other industrial neighborhoods of Chicago.

The community would reinvent itself. In recent years, some factories have been converted to residential lofts. The condominium boom resulted in new construction in the 1990s and early 2000s. The arts has become a new industry, and the Morris B. Sachs building—one of the neighborhood's tallest buildings—has been renovated and rebranded as the Hairpin Lofts and Arts Center. While people no longer move to Avondale to take jobs in factories, it has managed to remain a viable community and seems on track to continue as such for years to come.

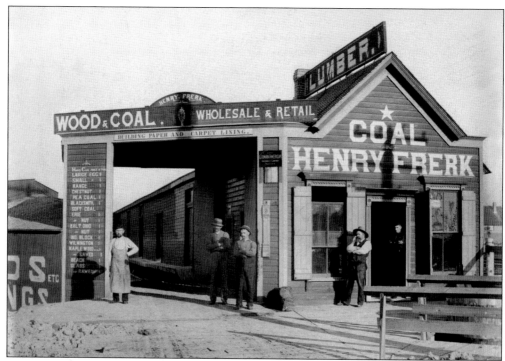

Henry Frerk & Sons coal and lumber business arguably built much of the "neighborhood that built Chicago," and it is still in business today. Frerk, born in Prussia in 1848, moved to Ohio and then to Chicago in the 1860s. In the early 1870s, he opened several grocery and provisions stores farther south along Milwaukee Avenue before purchasing property and opening a lumber and coal yard near the Avondale station at Belmont and Kedzie Avenues in 1887. The yard is still in business today at Belmont and Albany Avenues. This photograph shows the lumberyard in 1888, one year before the area was annexed to Chicago. (Courtesy Matthew Wolf.)

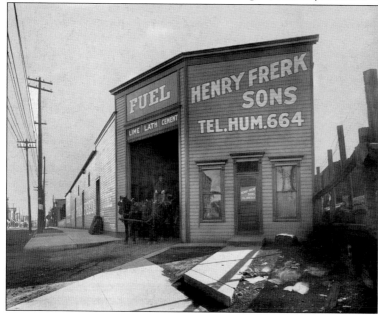

Around 1900, Frerk constructed a second-floor addition and enclosed warehouse, shown here shortly after construction. At this time, the neighboring Chicago & North Western tracks had not yet been elevated. (Courtesy Matthew Wolf.)

This 1908 photograph shows two generations of Frerks. Alfred (left), Henry (center), and Otto Frerk are sitting on a wood lath. Henry would die two years later, in 1910, at the age of 62. (Courtesy Matthew Wolf.)

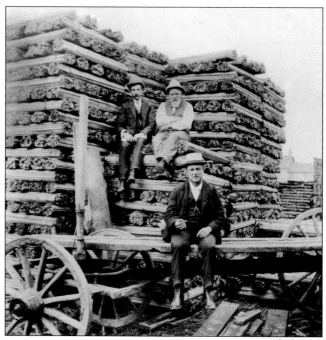

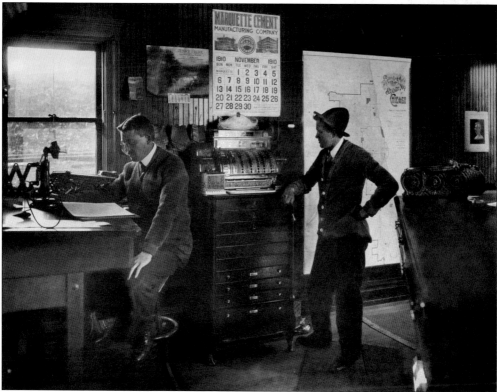

This 1910 photograph shows Frerk & Sons' Belmont Avenue office. Alfred (left) records the daily transactions in a ledger as Otto looks on. Note the map of Chicago at right. Today, the operation still conducts business in this office with the original wood paneling. (Courtesy Matthew Wolf.)

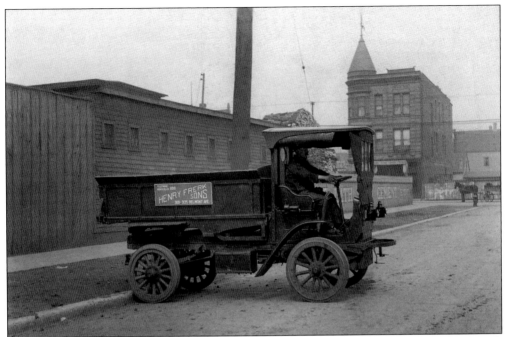

Otto Frerk was quick to purchase automobiles to add to his fleet of delivery horses. This dump truck dates to the late 1910s and was used by Frerk until the late 1940s. (Courtesy Matthew Wolf.)

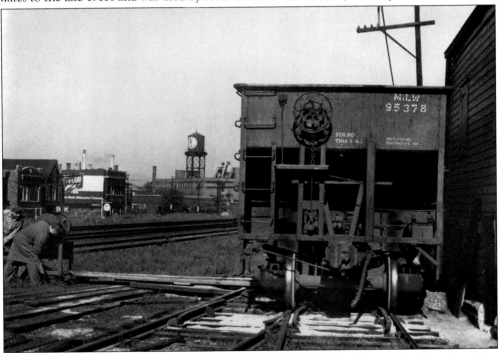

In 1945, workers are shown unloading a sand delivery from a railroad car on Frerk's siding. This view would change drastically over the next 15 years, as the buildings to the left were demolished for the Northwest (later Kennedy) Expressway. Klein Tools and its water tower are visible to the left of the railcar. (Courtesy Matthew Wolf.)

Coal was a major heating fuel for Chicago homes and businesses until the 1950s. Henry Frerk's coal hoppers are shown here in 1947, shortly before they burned down. (Courtesy Matthew Wolf.)

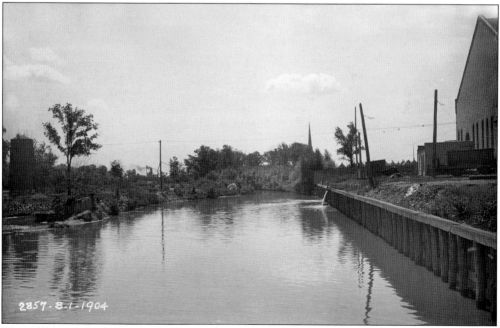

This 1904 view looks south along the Chicago River near Addison Street. The rural nature of the waterway is still evident. The Metropolitan Sanitary District was in the process of dredging and straightening the channel. The steeple of Concordia Evangelical Lutheran Church is visible to the right of center. (Courtesy Illinois State Archives.)

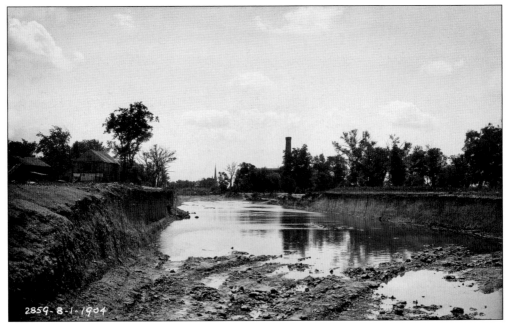

This 1904 view also looks south along the Chicago River from Addison. The river channel was soon to be widened and dredged to improve navigation and increase flow from the upstream North Shore Channel and Skokie sewage treatment plant. The smokestack of the Chicago Electric Transit Company (later Chicago Railways Company) powerhouse at Roscoe Street and California Avenue is visible. This coal-generating plant provided electric power to Chicago's nascent streetcar system. (Courtesy Illinois State Archives.)

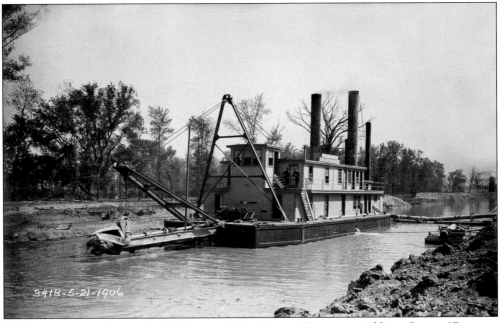

Dredging is proceeding in this 1906 view of the Chicago River near Addison Street. (Courtesy Illinois State Archives.)

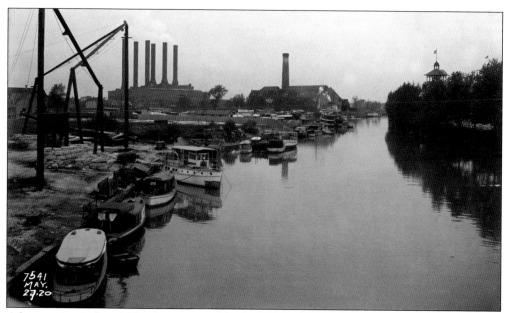

A burgeoning industrial landscape is visible along the Chicago River north of Belmont Avenue in 1920. Visible at left is the Peter Kargard boatyard (soon to become the Henry Grebe & Co. boatyard). Also shown are the smokestacks of the Northwest Station of Commonwealth Edison and the Chicago Railways Company powerhouse. At right is part of Riverview Park. Grebe's yard would produce numerous yachts and warships over the years and was a longtime landmark in Avondale. (Courtesy Illinois State Archives.)

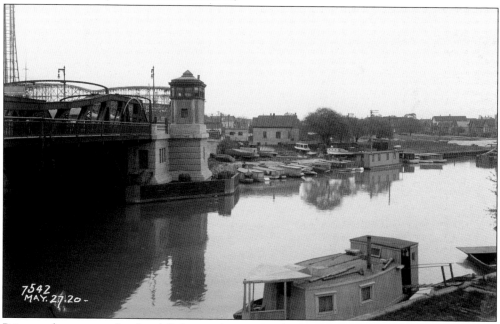

Prior to the present-day fixed Belmont Avenue Bridge over the Chicago River, there was a bascule drawbridge here, the third bridge at this location. Installed in 1917, it is seen in this 1920 photograph looking east. Riverview Park is visible at left. This bascule bridge was replaced by today's fixed bridge in 1976. (Courtesy Illinois State Archives.)

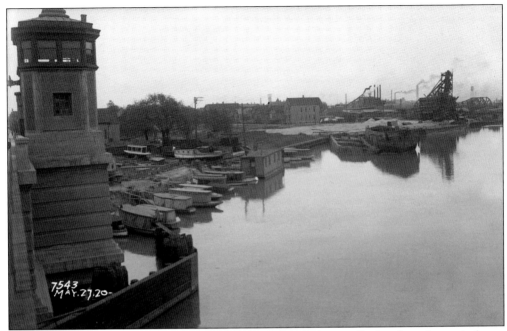

This 1920 photograph looking southeast from the Belmont Avenue Bridge shows heavy industry lining the river. The Chicago River was historically an industrial waterway, with many tanneries, steel-processing plants, and other heavy industrial uses along its banks. (Courtesy Illinois State Archives.)

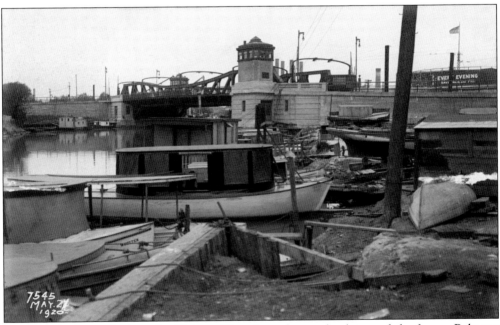

This view looks north along the Chicago River from the east bank toward the former Belmont Avenue drawbridge. As shown in this 1920 photograph, the banks of the river were often lined with discarded boats, houseboats, and other detritus. (Courtesy Illinois State Archives.)

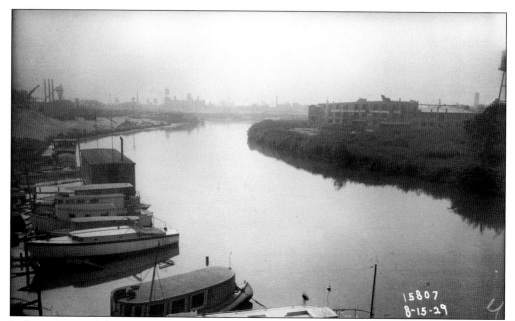

Industrial Avondale is seen through the haze to the south of the Belmont Avenue Bridge. The former Greenebaum Tanning Company is visible at right in this 1929 photograph. Tanneries were big business along the Chicago River. Leather goods were often produced by skilled German workers at these facilities. Part of the former Greenebaum tannery burned down in a major fire in 2013. (Courtesy Illinois State Archives.)

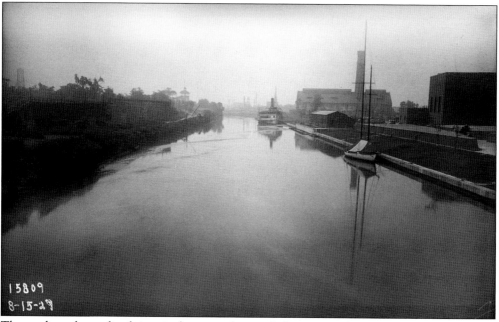

The modern channelized river is shown in this south-facing view from Addison Street in 1929. The Chicago Railways Company powerhouse is visible at right, as well as the docks that served this plant and presumably the neighboring Commonwealth Edison Northwest Generating Station. (Courtesy Illinois State Archives.)

This 1906 photograph of Milwaukee Avenue at Dawson Street shows western Avondale in relative infancy. Milwaukee Avenue is a muddy road with streetcar tracks. Frame buildings line the avenue. Not 20 years later, this scene would offer a completely different view, as the area was transformed into a major retail district. (Photograph by Chicago Daily News, Inc., courtesy Chicago History Museum, DN-0004229.)

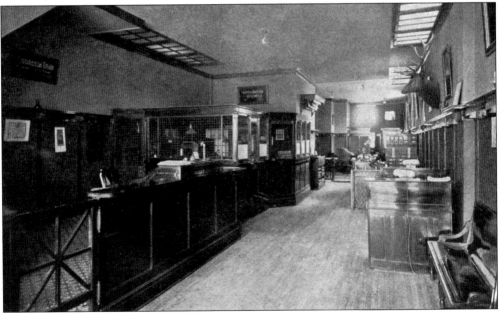

One of the major real estate developers in the western part of Avondale was Haentze & Wheeler, located at the southwest corner of Belmont and Milwaukee Avenues. The interior of the real estate office is seen here in August 1913. Haentze & Wheeler developed the upscale Villa District northeast of Pulaski Road and Addison Street beginning in 1907. (Courtesy Villa Improvement League.)

Fire protection was important in rapidly growing Avondale. This still-extant firehouse building at the corner of Elbridge and Central Park Avenues is seen shortly after construction in 1901. It was home to Engine Company No. 91 until it moved to Pulaski Road and Diversey Avenue in 1982. It is now home to the Puerto Rican Arts Alliance. (Courtesy Ken Little.)

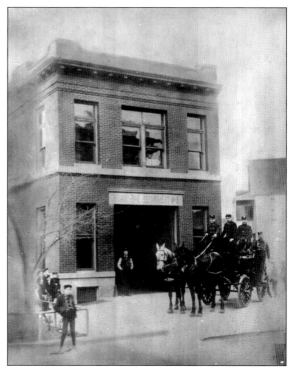

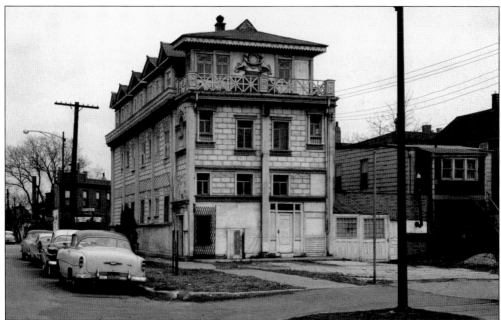

In Avondale, a neighborhood of simple frame and brick structures that housed generations of factory workers, this fancy house is an oddity. No longer standing, it was located at 2856 North Campbell Avenue, near Elston Avenue. The house, seen here in 1960, appears to have been constructed out of concrete block. It was completed in 1889 for owner H. Bartells, according to building permit archives. (Photograph by Glenn E. Dahlby, courtesy Chicago History Museum, ICHi-68005.)

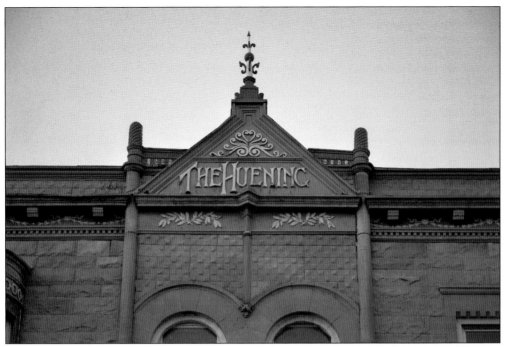

This close-up of the Huening Building at 2855 West Belmont Avenue shows original intact details from 1896. The existing craftsmanship on this building is remarkable considering its age. (Courtesy Mark Dobrzycki.)

The Queen Anne–style Huening Building reflects the Germanic influence in eastern Avondale. Architectural details are plentiful on this ornate structure. (Courtesy Mark Dobrzycki.)

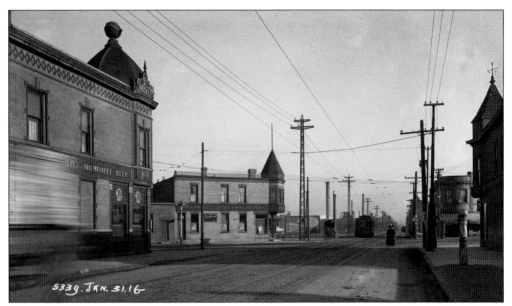

The intersection of Elston, Western, and Diversey Avenues is shown here in 1916, looking southeast down Elston. The working-class nature of the area is evident in the saloons located on each corner. No less than three taverns are visible, advertising Schlitz, Pabst, and Brand beer, a local Chicago brewer and owner of Brands Park (see page 76). The Schlitz tavern at left is surely a tied house, an establishment set up by a brewery to sell only its brand of beer. This practice was outlawed after Prohibition. (Courtesy Illinois State Archives.)

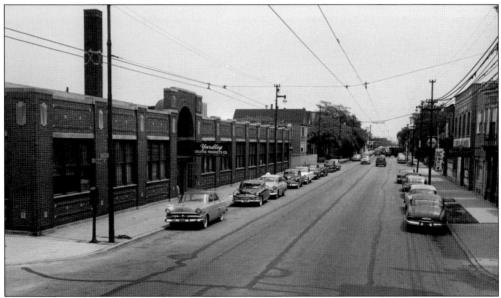

While much of the industrial development of Avondale followed the river and railroad corridors, other factories were built along commercial streets, such as Belmont Avenue. This 1954 photograph shows the Yardley Created Products Company (a plastics manufacturer) on the northeast corner of Belmont and Drake Avenues. Trolley wires above the street powered electric trolleybuses, which replaced streetcars on Belmont Avenue in 1949. (Courtesy Chicago Park District Special Collections.)

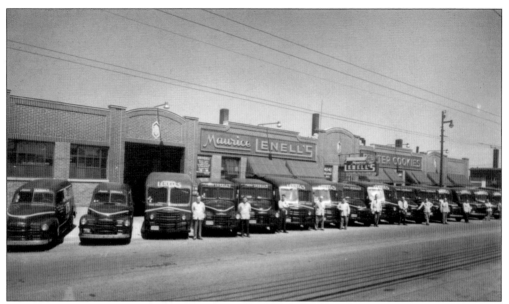

A longtime fixture in Avondale was the Maurice Lenell cookie factory, located for years at 4040 West Belmont Avenue after relocating from an earlier Milwaukee Avenue location. These famous butter cookies are still a Chicago favorite, though they are no longer manufactured in Chicagoland. The bakery was founded in 1925 by Swedish brothers Hans and Gunnar Lenell; the company moved production to suburban Norridge in the 1950s. This building still stands today and is used for retail. Interestingly, the notable Polish mural *Razem* was painted on the east wall of this building in 1975 (see page 59). (Courtesy Jill Bocskay-Cardalucca.)

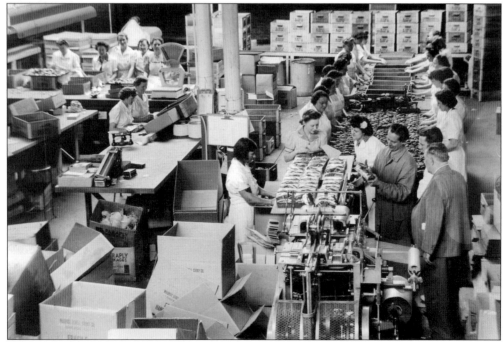

This rare interior view of the Maurice Lenell cookie factory on Belmont Avenue shows the production of Lenell's famous product. (Courtesy Jill Bocskay-Cardalucca.)

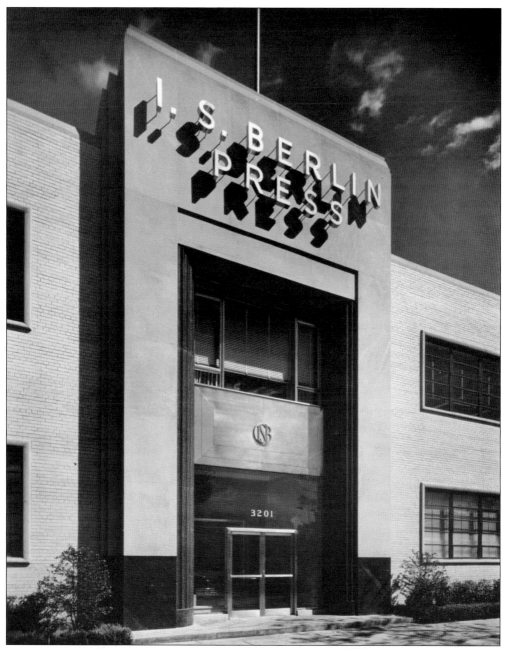

A major industrial landmark in Avondale was I.S. Berlin Press, at the northeast corner of Belmont and Kimball Avenues. Chicago was the center of the printing industry, and Avondale played a central role. I.S. Berlin, founded in 1920, was located in the Printer's Row area until construction of the Congress Expressway required its relocation. It moved to this plant, built in 1949 and designed by A. Epstein & Sons, architects. The plant is seen here shortly after completion. (Courtesy Epstein.)

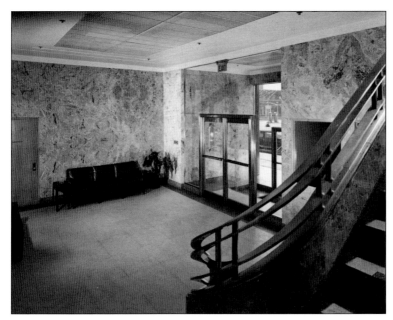

Inside the I.S. Berlin building's main entrance on Kimball Avenue was this beautifully designed Italian marble lobby of Art Moderne design. This photograph dates from 1949, shortly after the building's opening. (Courtesy Epstein.)

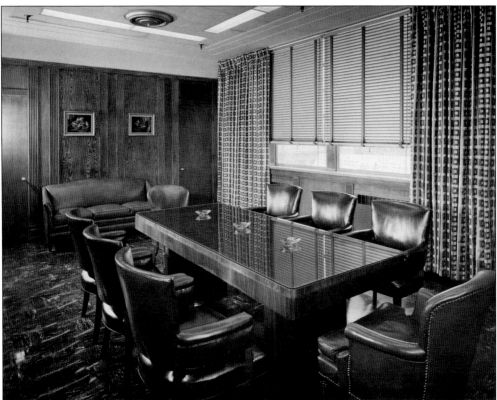

Smoke up, Johnny! This was the upstairs boardroom of the I.S. Berlin building in 1949, shortly after opening. There are plenty of ashtrays to go around. Top-quality materials were used throughout the construction of this plant, which printed color advertising literature, children's books, and many other products, all with the lithography process. (Courtesy Epstein.)

Company president I.S. Berlin looks quite content in his upstairs office in 1949. Locally owned manufacturers and printers like Berlin employed hundreds of thousands of people in the Chicago area. This was the heyday of post–World War II industrial Chicago, and Avondale played a major role. (Courtesy Epstein.)

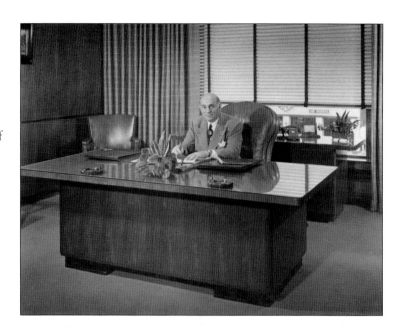

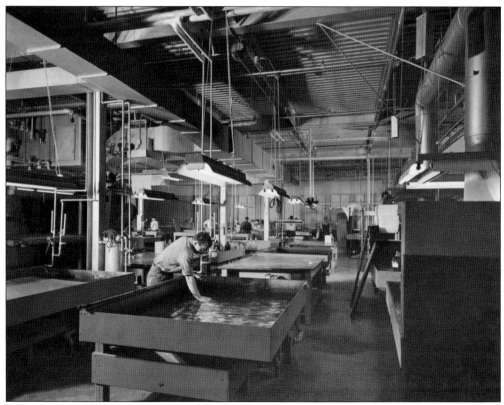

When it opened its plant in 1949 at Belmont and Kimball Avenues, I.S. Berlin employed over 500 workers. Shown here is a portion of the production process in 1949. Photographs like this are rare to find today, but they show what was previously a common facet of everyday life for thousands of Chicagoans: the factory floor. (Courtesy Epstein.)

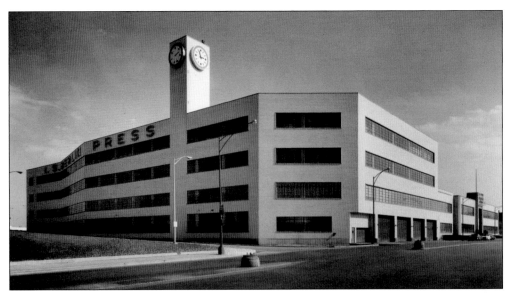

I.S. Berlin was the world's largest commercial lithographing company when it announced a $2.5 million expansion in 1960. Coinciding with the neighboring construction of the Northwest (later Kennedy) Expressway, this modernist addition by A. Epstein & Sons, architects, was just completed when this 1961 photograph was taken. The building reflected the curve of the expressway, and the clock at the top was an Avondale landmark until the entire plant was demolished for the Kennedy Plaza shopping center in 1977, a reflection of changing trends in manufacturing that cost Avondale and other industrial Chicago neighborhoods thousands of jobs. (Courtesy Epstein.)

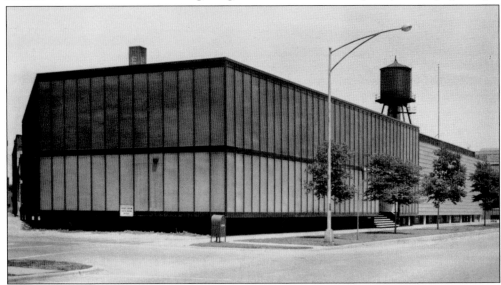

Architect Bertrand Goldberg, most noted for Marina City and the now-demolished Prentice Women's Hospital, designed this auto-parts factory on the fringes of Avondale. The E. Edelmann & Company factory addition is shown here soon after completion in 1960, at the corner of Jones Street and Logan Boulevard. The unique window treatments and cantilevered design reflect Goldberg's forward-thinking design principles. This structure, since altered, is today a self-storage facility. (Edelmann Company, addition, Chicago, IL, c. 1960. Bertrand Goldberg, architect. Bertrand Goldberg Archive, Ryerson and Burnham Archives, The Art Institute of Chicago.)

The industrial corridors of Avondale were not simply devoted to manufacturing; warehousing was a common use as well. This former warehouse building at 2630 North Pulaski was designed by A. Epstein, architects. First constructed in 1924, it was expanded in 1941. The building, seen here in 1947, served as a grocery, cold storage, and bakery warehouse for Chicago-area stores of the Great Atlantic & Pacific Tea Company (A&P), a major chain grocer. The building still stands and is now home to ClimateGuard Windows and Doors. (Courtesy Epstein.)

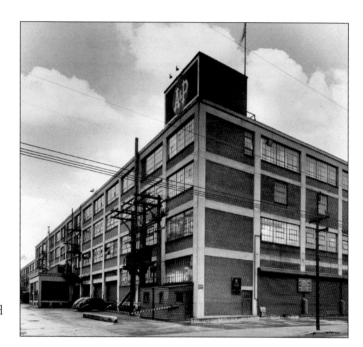

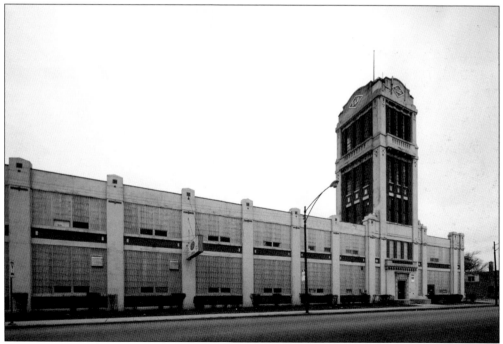

A major industrial landmark in Avondale is the Ilg Electric Ventilating Company building. It was completed in 1920 at 2850 North Pulaski by noted Chicago architect Alfred Alschuler for fan inventor Robert Ilg. A major manufacturer of electric fans, Robert Ilg also notably built the famous Leaning Tower of Pisa replica in 1932 in Niles as a pleasure ground for his employees. The Ilg company went out of business in 1990, but the building remains as a great example of a common thread in Chicago factory design: a prominent decorative tower that skillfully hides the water tower and becomes a local landmark. (Courtesy John Morris.)

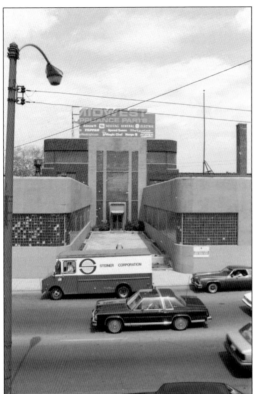

Not only was Avondale home to numerous industrial buildings, many of them were (and still are) architecturally significant. This Art Moderne building at 2600 West Diversey Avenue was built for the American Electric Fusion Company, manufacturer of electric welders. It was later home to Midwest Appliance Parts and the Northwest Community Mental Health Center. It no longer stands. (Photograph taken for the Chicago Historic Resources Survey, courtesy Commission on Chicago Landmarks.)

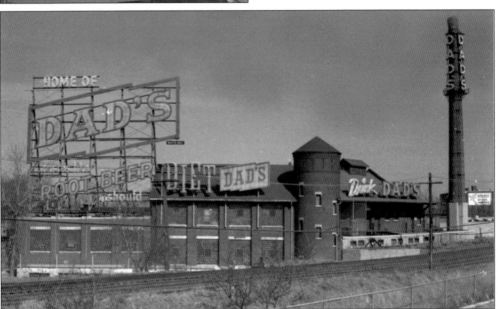

A landmark for generations of drivers on the Kennedy Expressway, as well as for riders on the neighboring Chicago & North Western Railway, was the Dad's Root Beer factory on Washtenaw Avenue, near Diversey Avenue. This building was initially constructed as part of a Borden's Dairy complex in 1924 and designed by architect Eben Roberts. It was home to Dad's for many years. (Courtesy Matthew Schoenfeldt.)

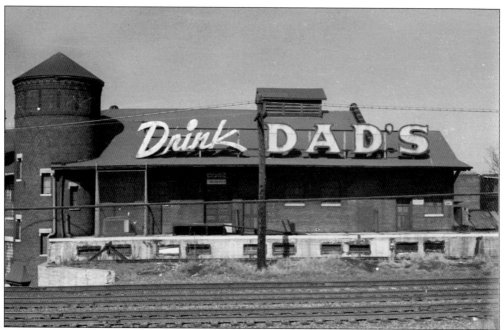

Dad's Root Beer was created in Chicago in 1937 by Ely Klapman and Barney Berns. While most of the Dad's Root Beer factory is now gone, the turret structure at left has been saved as part of a new condominium development; however, the dazzling neon display is now history. (Courtesy Matthew Schoenfeldt.)

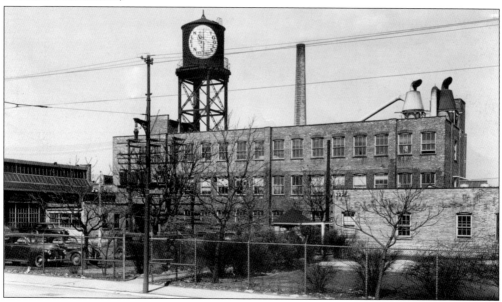

In 1857, Mathias Klein started manufacturing tools in downtown Chicago for the burgeoning telecommunications (then telegraph) industry. The company grew and set up shop on Belmont Avenue just west of Kedzie in the early 20th century. This undated photograph shows the Avondale plant. Construction of the Northwest Expressway in the 1950s necessitated the removal of this factory, and the company relocated to suburban Lincolnwood. Klein is still in business today. (Courtesy Klein Tools.)

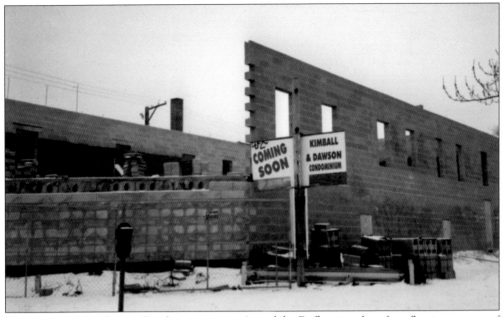

This is one of the shortest-lived structures in Avondale. Reflecting the often-fleeting nature of Chicago development, construction of these condominiums on the site of a former city-owned parking lot at Kimball and Dawson Avenues began in 2002. It stalled in 2003, and the abandoned carcass shown here was demolished in 2004 shortly after this photograph was taken. The site then sat vacant until a medical clinic was recently built on the site. (Courtesy Dan Pogorzelski.)

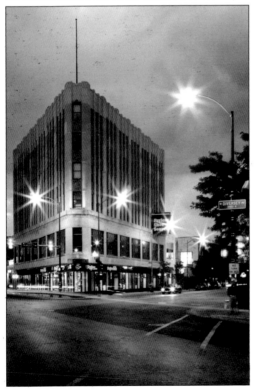

Both Avondale's rapid growth and its recent rebirth are reflected at the major retail intersection of Diversey, Milwaukee, and Kimball Avenues. The Art Deco Hairpin Lofts building was built in 1930 by architects Leichenko and Esser for Sol Goldberg, owner of the Hump Hair Pin Manufacturing Company. It was later home to the Morris B. Sachs department store. After its upper floors sat vacant for years, it was restored and became the Hairpin Lofts and Arts Center, which opened in 2012. (Courtesy chicagopatterns.com.)

Three

A CHURCH FOR
EVERY NATION

Avondale is often typecast as a neighborhood of smokestacks and steeples. While many of the chimneys stand silent as industry has left the neighborhood, the tall spires in the Avondale skyline still endure. Built by diverse peoples practicing a variety of Christian creeds, the urge to construct these holy buildings sprung from the desire to create an enduring home in a new place. Churches were often the first buildings erected by residents as they settled Avondale—a social necessity of their way of life. This fact was not lost on developers, who for this reason were sometimes willing to donate lots for houses of worship in a bid to drum up sales of adjacent property.

The design of these sacred spaces ranges wildly in scale, from simple bungalows to towering edifices proclaiming God's grandeur. St. Hyacinth Basilica, as one of only three basilicas in Chicago, holds the unique honor of having been designated a Minor Basilica, its immense size and scope a testament to Avondale's large Polish community. Little wonder that in the eyes of locals it was "the Polish Cathedral," an observation that gave rise to its own designation in the field of sacred architecture. Yet, even the most modest structure assembled with the proverbial "widow's mite" was of the utmost importance to the congregation that built it.

It is also important to keep in mind that, for most congregations, ethnicity played a key role in the founding, as well as in the life of, these religious communities. The architecture and design of these precious buildings often bears witness to the heritage of its founding fathers. The long and elegant spire of Concordia Evangelical Lutheran Church, which until recently welcomed passersby as they crossed the Chicago River heading west on Belmont Avenue into Avondale, was indistinguishable from similar steeples dotting the landscape in the German Alps. Even for Roman Catholics in Chicago (who, until the conclusion of the Second Vatican Council in 1965, worshipped in Latin), it was ethnicity and not proximity that dictated a parish's population, a truth that generally held firm until recently. The result is a rich legacy for the people of Avondale and Chicago's Polish Village to take pride in and for the visitor to enjoy.

The Plymouth Brethren is an Evangelical church originating in Dublin, Ireland, in the 1820s. The story of its assembly in Avondale originated with K.J. Muir moving into the area in March 1887. By the fall of 1888, Muir, along with John Arnold, Cuthbert D. Potts, and their families, would form the nucleus of the Avondale Assembly. Continuing the traditions of this spiritual movement is the Local Evangelico de Avondale, located at 2814 North Sawyer Avenue and serving a predominately Latino congregation. (Courtesy Mark Dobrzycki.)

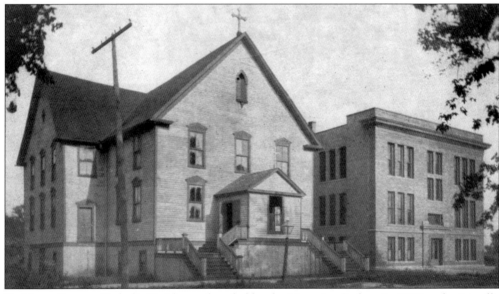

St. Viator Roman Catholic Parish was founded by the Viatorian Fathers in 1888 and originally sited on Pulaski Road just north of Belmont Avenue. St. Viator sold this property in 1911 and is currently located at 4170 West Addison Street in Old Irving Park. While the original church is long gone, the school building at right in this 1890 photograph still stands as the Maid-O-Mist Factory at 3217 North Pulaski Road. (Courtesy St. Viator Roman Catholic Parish.)

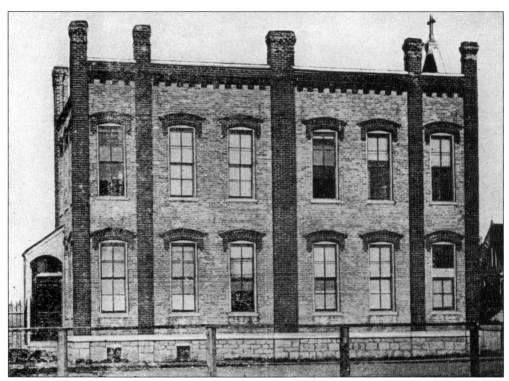

St. Francis Xavier Roman Catholic Church began as a mission of St. Aloysius. This brick structure was built over the course of the summer of 1888 to serve as its first place of worship. Founded as a German national parish, the building was erected facing Warsaw Avenue, which was changed to Nelson Avenue in 1936. The building was later demolished. (Courtesy Resurrection Roman Catholic Church.)

By 1892, a new, larger church was erected next to the first structure on Warsaw Avenue (now Nelson Avenue), as seen in this 1907 photograph. It was built under the leadership of Fr. Edward Goldschmidt, the son of a rabbi. This edifice was later torn down after the completion of the current church building in 1929. It is now the site of the parish parking lot. (Courtesy Resurrection Roman Catholic Church.)

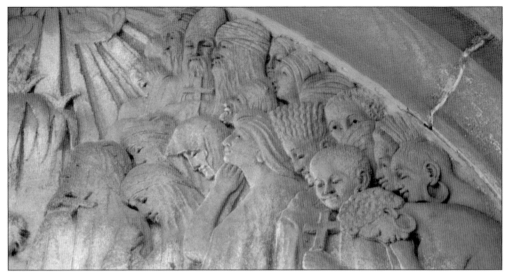

St. Francis Xavier was founded as a German national parish, but the exodus of Germans and Swedes out of Avondale and the influx of Eastern Europeans into the area altered the character of this community of faith. By the 1920s, St. Francis Xavier had a multiethnic congregation, with members who were "Polish, Bohemian, and even some Irish." These bas-reliefs by Władyslaw "Walter" Gawliński on the church exterior enriched the distinctly Teutonic character visible in the architectural decor of the building itself. The congregation today serves as a spiritual center for Avondale's Filipino and Latino communities. A sign at the church's entrance welcomes visitors in English, Tagalog, and Spanish. (Courtesy Mark Dobrzycki.)

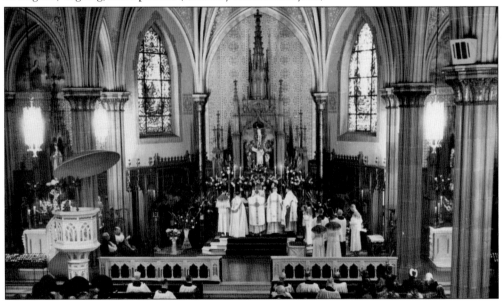

The current church was completed in 1929. This 1948 photograph illustrates the colorfully decorated interior of St. Francis Xavier prior to renovation work that substantially altered the church in 1984. Many Roman Catholic churches were similarly transformed in accordance with changes in liturgy adopted by the Second Vatican Council (1962–1965). In 1991, St. Francis Xavier merged with nearby St. Veronica's Roman Catholic Church to become Resurrection Roman Catholic Church. (Courtesy Resurrection Roman Catholic Church.)

Concordia Evangelical Lutheran Church at 2649
West Belmont Avenue was founded as a German
congregation, a tradition that this now multiethnic
and multicultural congregation still celebrates. It
was completed in 1893 according to plans drawn
up by Frederick Ahlschlager, who also designed
the former Anshe Emet Synagogue at 1363 North
Sedgwick Street. The church steeple seen here
was a longtime hallmark of the Avondale skyline
until it was forcibly removed after it sustained
damage in 2013. (Courtesy Mark Dobrzycki.)

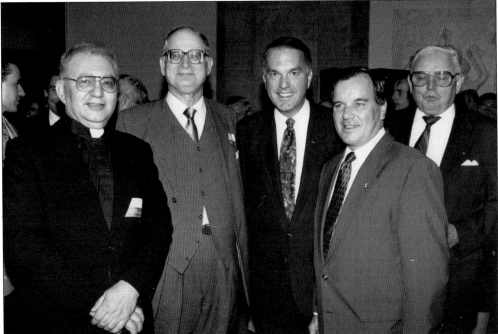

Hapsburg prince Arnold zu Windischgraetz (left) was the longtime pastor of Concordia Evangelical
Lutheran Church. This son of Austro-Slovenian nobility was a man of faith and culture. In his
obituary, the *Chicago Tribune* noted how his home served as a veritable cultural node no less
cosmopolitan than the Austro-Hungarian Empire: "Church leaders from around the world would
be at parties where conversations could be heard in Polish, French, German, and other languages."
Even former Mayor Richard M. Daley (second from right) was eager to take a photograph with
the lively pastor. (Courtesy Concordia Evangelical Lutheran Church.)

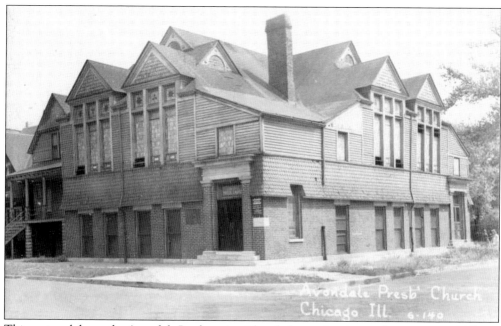

This postcard shows the Avondale Presbyterian Church, located at the northeast corner of Albany Avenue and School Street. This 1891 structure is still standing. The building later served as the Richard F. Mell Social Athletic Club. (Courtesy Northwest Chicago Historical Society.)

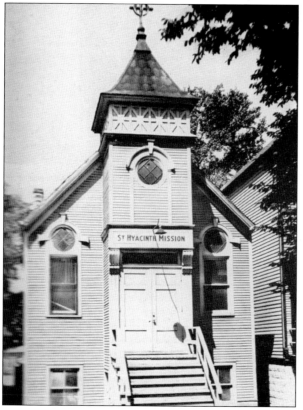

St. John's Evangelical Lutheran Church, organized in 1904, is indicative in telling the saga of Swedes in the Avondale area. This church was built in 1907 at the southeast corner of Christiana and Barry Avenues by Swedish Lutherans, once a substantial group in the community. By 1916, the congregation was already looking at selling the property, as Swedes continued to leave the neighborhood. The parish was dissolved in 1942, and the building was sold to St. Hyacinth's Roman Catholic Church for use as a mission. (Courtesy St. Hyacinth Basilica.)

In 1894, St. Hyacinth Basilica was founded by Polish Roman Catholics who, prior to this, had worshipped at St. Francis Xavier's, a German Roman Catholic Parish. From its inception until the present day, St. Hyacinth has been run by the Resurrectionist Order. The origins of this spiritual community among Polish refugees in Paris is commemorated on the westernmost set of bronze doors at the front of the church, designed by Czesław Dźwigaj. (Courtesy St. Hyacinth Basilica.)

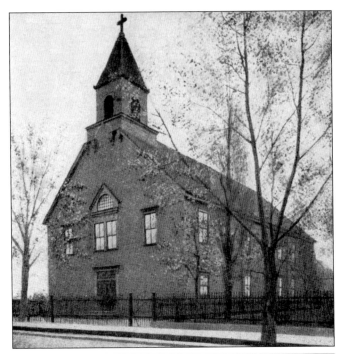

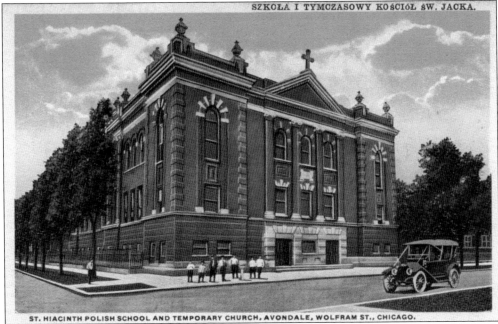

SZKOŁA I TYMCZASOWY KOŚCIÓŁ ŚW. JACKA.

ST. HIACINTH POLISH SCHOOL AND TEMPORARY CHURCH, AVONDALE, WOLFRAM ST., CHICAGO.

Originally located at the southwest corner of Milwaukee and Central Park Avenues, where the Orbit Building now stands, St. Hyacinth was moved to its current location between George and Wolfram Streets, just east of Lawndale Avenue. This postcard shows the combination school and church for St. Hyacinth that was located at the corner of Lawndale Avenue and Wolfram Street. Dedicated on December 16, 1906, by Archbishop James E. Quigley, this building was razed in 1962. Resurrection Hall (which opened in September 1963) now stands on the site. (Courtesy Lake County [IL] Discovery Museum, Curt Teich Postcard Archives.)

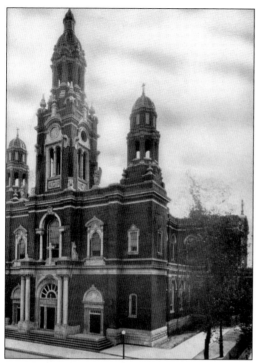

The current church building was erected between 1917 and 1921 and designed by the firm of Worthmann and Steinbach. The size and grand scope of this structure is worthy of its popular, albeit inaccurate designation as a "Polish Cathedral." With seating for 2,000, there is standing room only at some of the Sunday masses, with an estimated attendance of nearly 10,000 coming to St. Hyacinth for services every weekend. (Courtesy St. Hyacinth Basilica.)

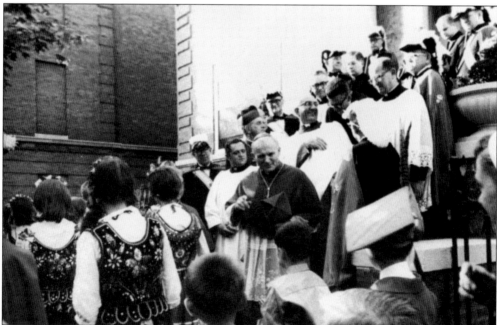

Pope John Paul II visited St. Hyacinth not once, but twice as Karol Cardinal Wojtyła, the Archbishop of Cracow, Poland, before his election to the Throne of St. Peter. Here, an assembly of the Knights of Columbus and girls dressed in Polish folk outfits greet the future pontiff on the steps of the rectory. Thanks to the efforts of Józef Cardinal Glemp and Pope John Paul, St. Hyacinth was officially designated a Minor Basilica in 2003, an honor shared with only two other churches in the Chicagoland area. (Courtesy St. Hyacinth Basilica.)

St. Hyacinth continues to be a vital community center for Chicago's Polish residents. Presidents, dignitaries, and other notable guests from Poland have all visited this cornerstone of Polish Chicago. Here, Golec uOrkiestra, a well-known Polish folk jazz outfit, plays a holiday concert at the basilica in 2013. The group's lyrics were quoted by Pres. George W. Bush during a speech in 2001. (Courtesy Dariusz Lachowski.)

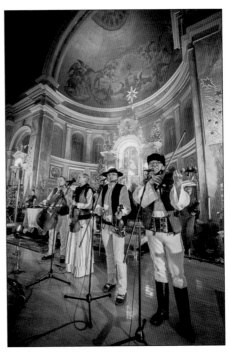

St. Hyacinth's Mission of our Lady of Lourdes was purchased from St. John's Evangelical Lutheran Church, a Swedish congregation that dissolved in 1942, to relieve overcrowding at the main church. Yet, even this space was insufficient, and the original structure had to be torn down and replaced with the current mid-century modern structure completed in 1956 at the southeast corner of Christiana and Barry Avenues. Today, it houses a Traditionalist Catholic chapel run by the Canons Regular of St. John Cantius, serving the Latino community. (Courtesy Jacob Kaplan.)

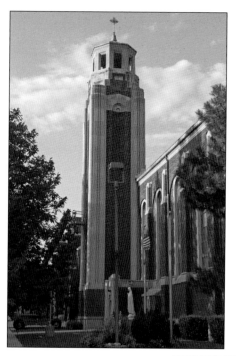

As Poles continued to pour into Avondale, a new Polish Roman Catholic parish was created in 1912. A frame building that previously served as a school and meeting hall at St. Hyacinth's was moved and became the first church for the new parish of St. Wenceslaus. The stately Art Deco structure seen here was designed by the firm of McCarthy, Smith, and Eppig and completed in 1940. The church contains a purgatorial shrine by esteemed Polish painter Jan Henryk de Rosen, famous for his mural work in the Armenian Cathedral of L'viv in Ukraine. Still run by the Resurrectionist Order, the parish today serves a diverse congregation of Poles, Latinos, and Filipinos, as well as new arrivals to the neighborhood as it undergoes gentrification. (Courtesy Robert Magala.)

St . Veronica's Roman Catholic Church was founded in 1904 at 3300 North Whipple Street as a territorial parish to serve English-speaking Catholics in the Avondale area, chiefly the Irish, as well as children of ethnically mixed marriages who desired a Catholic community that was culturally neutral. However, the importance placed upon ethnic bonds by Avondale residents at the time proved to be the parish's eventual undoing, as the congregation was never able to build a separate structure for worship aside from the "provisional" space in the combination school/church building. In 1991, this parish was merged with St. Francis Xavier to form Resurrection Roman Catholic Church. (Courtesy Resurrection Roman Catholic Church.)

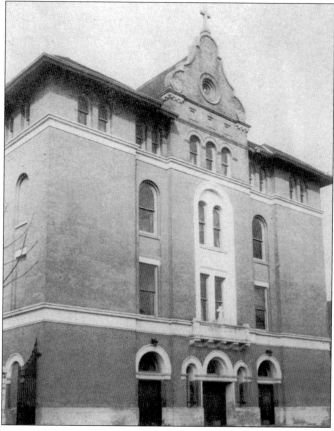

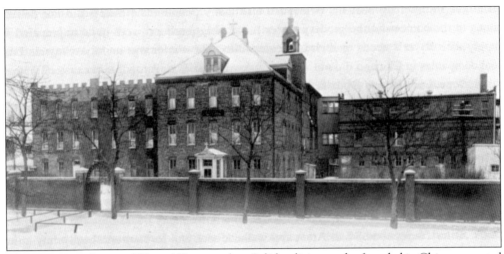

The Franciscan Sisters of Blessed Kunegunda, a Polish religious order founded in Chicago, started construction on this compound at Hamlin and Schubert Avenues in the Kosciuszko Park area in 1897. St. Joseph Home for the Aged and Crippled, as the facility was called, served as the city's first Catholic nursing home. In 1928, this edifice was replaced by a vast complex, taking up nearly a city block, designed by Slupkowski and Piontek, an architectural firm associated with some of the most prestigious buildings in Chicago's Polish downtown. The site is now an empty lot, and St. Joseph's relocated to a new facility on Belmont Avenue just west of Pulaski Road. (Courtesy St. Joseph Village.)

Aside from the Catholic Church, religious structures often change hands as ethnic settlement shifts across different neighborhoods throughout Chicagoland. The Philippine American Ecumenical Church at 3533 North Albany Avenue (shown here) serves as a case in point. The previous owner of this structure was Gethsemane Romanian Pentecostal Church, and Sanborn Fire Insurance maps indicate that this was the site of St. John's Episcopal Chapel in 1913 and St. Stephen's Episcopal Church in 1949. (Courtesy Mark Dobrzycki.)

All Saints Orthodox Church is a parish of the Antiochian Orthodox Christian Archdiocese of North America. Located at 4129 West Newport Avenue, it formerly housed Bethany Lutheran Church, a Norwegian congregation that built this structure. All Saints was the founding parish of Ancient Faith Radio, which features liturgical music from a variety of Orthodox traditions, as well as prayers, readings, lectures, and interviews. (Courtesy Jacob Kaplan.)

St. Nicolai United Church of Christ was founded by German settlers in 1889. The second church building, erected in 1916, lasted until construction of the Kennedy Expressway necessitated its demolition and relocation to a new, modern building completed in 1956 at the northwest corner of Wellington and Kedzie Avenues (see page 96). Today, this multicultural congregation reflects the diversity of the neighborhood around it and serves as the regular meeting place for the West Logan Square/Avondale Block Club. (Courtesy Mark Dobrzycki.)

Four

THE BEST GAME IN TOWN

Avondale and Chicago's Polish Village once served as the place for political elites to publicly hobnob for the support of the Polish American electorate. Politicians of both local and national prominence visited the area. These galas and meetings were usually a big affair, and they brought with them a palpable excitement to the community. No less a figure than the 41st president of the United States, George H.W. Bush, attended mass at St. Hyacinth during his 1988 campaign. Purportedly, violence almost broke out. Supporters of Lyndon LaRouche protesting outside the basilica were not looked at very kindly by local Poles, who had a reverence for Bush as the candidate they saw as the best hope against the loathed Communist regime in Poland.

Historical connections like this have brought the neighborhood into the spotlight and have served it well during the heated fight to preserve the Orbit Building at Central Park and Milwaukee Avenues from demolition in the first decade of the new millennium. The fact that Pres. Bill Clinton had dined in the longtime Polish restaurant that gave the building its name was often repeated in the successful case that preserved this historic structure, designed by architect Henry L. Newhouse.

Interestingly enough, Avondale and Chicago's Polish Village still continue as a political hotbed for citizens of the country of Poland. Since the end of communism in 1989, St. Hyacinth has served as a polling place where Poles are able to vote in elections for president, for the Polish Parliament (known as Sejm), and for representatives in the European Parliament in Brussels. The result has been a stream of government officials and candidates from Poland making campaign stops here. Among those who have visited here are two presidents of Poland, Nobel Peace Prize winner and former Solidarity leader Lech Wałesa, and Lech Kaczyński (who tragically passed away in April 2010 in Smolensk, Russia). President Kaczyński's twin brother, former premier Jaroslaw Kaczyński, and MPs of his Law and Justice Party (Prawo i Sprawiedliwosc), such as Adam Kwiatkowski and Antoni Macierewicz, have also paid official visits. These tours have been a decidedly multipartisan affair, including leaders of various political factions and ideologies active in Poland.

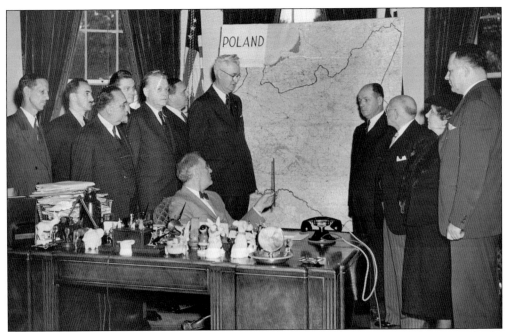

The Polish electorate was a vital part of the Democratic Party. Karol (Charles) Rozmarek (far right) was one Avondale resident with the clout to get into the Oval Office to meet with Pres. Franklin Roosevelt. As the head of the Polish National Alliance during World War II, he helped found the Polish American Congress in 1944. (Courtesy Charles Komosa.)

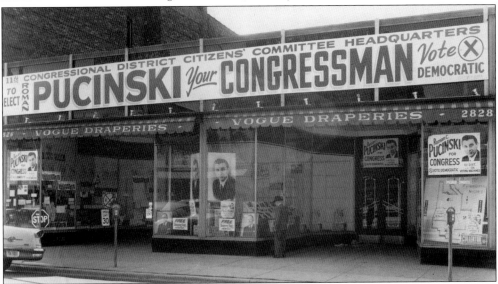

Congressman Roman Pucinski, a son of Chicago's 35th Ward, made sure to stay close to his home base in Avondale and Logan Square during his political career. These storefronts at 2826 and 2828 North Milwaukee Avenue served as the congressman's campaign headquarters during his first election to Congress in 1958 for Illinois's 11th Congressional District. Congressman Pucinski's two most important contributions during his seven terms in office were mandating the installation of "black box" flight recorders on all passenger airliners and pushing for federal assistance to community colleges. (Courtesy Aurelia Pucinski.)

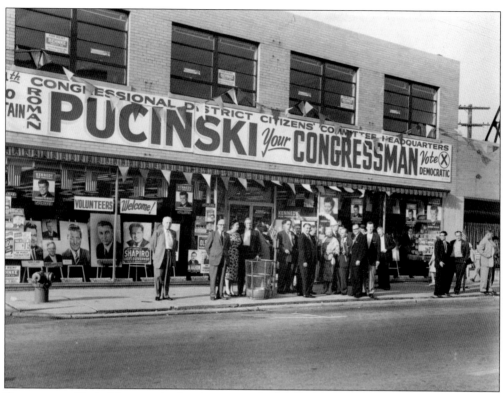

Congressman Pucinski's campaign headquarters at 3430 West Diversey Avenue is seen here in 1960. Displayed prominently in the storefront's numerous windows are posters promoting many other Democratic candidates running for office that year, including future president John F. Kennedy. This building appears very much the same today as it did in 1960. (Courtesy Aurelia Pucinski.)

Although known as the "Chief of Kostkaville" due to his family's longstanding role in the Pulaski Park neighborhood, Dan Rostenkowski proudly represented Avondale as congressman of the 8th Congressional District. This 1968 campaign office was located at the northwest corner of Milwaukee and Lawndale Avenues. Although the storefront window has since been bricked over, this building looks much the same today. (Courtesy Marty Cook.)

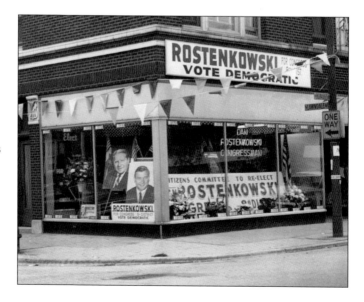

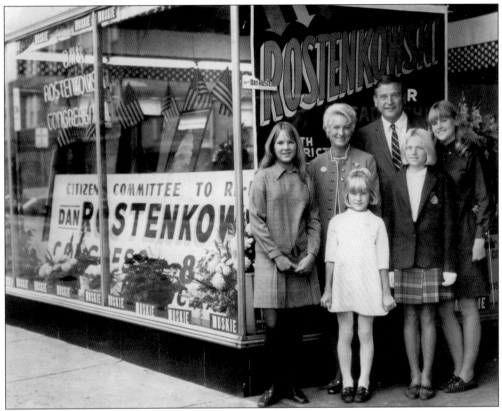

Congressman Dan Rostenkowski and his family pose in front of the campaign office in 1968. Charles Wheelan argues in his book *Naked Economics: Undressing the Dismal Science*, "We Chicagoans can drive around the city and literally point to things that Rosty built." The improvements he made possible have arguably improved the quality of life for Avondale residents. Rostenkowski helped secure the federal funds necessary for extending the CTA's Blue Line from Logan Square, first to Jefferson Park and later to O'Hare Airport. He secured $450 million to repave and expand the Kennedy Expressway, as well as $4 billion for the Deep Tunnel Project, which was designed to protect over half a million home owners threatened by basement flooding. (Courtesy Marty Cook.)

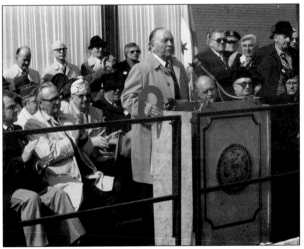

Mayor Richard J. Daley (at podium) appears at a 1976 ceremony for the future Copernicus Senior Center at 3160 North Milwaukee Avenue, named after the famed Polish astronomer Nicholas Copernicus. Although alderman of the 41st Ward, centered in Norwood Park at the time, native son Roman Pucinski (standing third to the right of Daley) returned to his home turf for the ceremony. (Courtesy Chicago Public Library, Special Collections and Preservation Division, DUR 12498.)

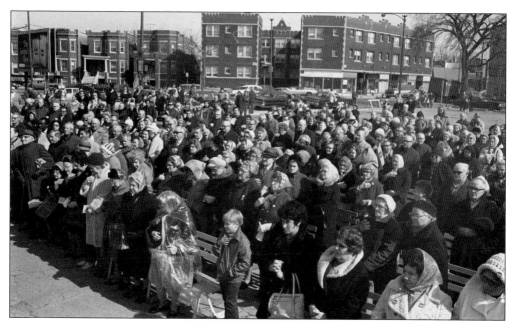

As shown in this photograph at the same event, Mayor Daley was able to draw a crowd. Located in a former Jewel Supermarket, the senior center was formally established after the mayor's death in 1977, the first such facility in the city of Chicago. Copernicus has undeniably been a success; currently, 100 senior citizen groups and clubs take part in programs at the center. (Courtesy Chicago Public Library, Special Collections and Preservation Division, DUR 12489.)

Future mayor of Chicago Richard M. Daley (left) is at Kosciuszko Park in 1976. At the time of this photograph, Daley was a state senator from Illinois's 23rd District, centered on the family's political home in the city's 11th Ward. Daley would run for state's attorney in 1980 before his unsuccessful attempt to become the Democratic Party's candidate for mayor in 1983. Persistence paid off, however, and in 1989 he became the 54th mayor of Chicago, a position he held for 22 years. (Courtesy Chicago Park District Special Collections.)

Mayor Jane Byrne (right) speaks with Bernie Hoffman (second from left), the owner of Animal Kingdom, on Central Park Avenue. They are seen at a parade organized by the Milwaukee-Diversey Chamber of Commerce. The photograph faces southeast, down Milwaukee Avenue. A native Northwest Sider, Mayor Byrne had a number of initiatives during her administration that were clearly aimed at courting the Polish American vote. (Courtesy Steve Maciontek.)

Avondale had one of the first female members of the Chicago City Council; Carole Białczak represented the 13th Ward from 1989 until 1995. She is pictured here with Ted Lechowicz (right). Now retired, Białczak currently serves on Mayor Rahm Emanuel's Advisory Council on Aging. (Courtesy Carole Białczak.)

Owner Matthew Słowik was a local Republican heavyweight. Having joined the 35th Ward Regular Republican Organization as precinct captain in 1952, he was elected the ward's Republican committeeman in 1956. Subsequently reelected in 1960 and 1964, Słowik served as a delegate to the 1960 Republican National Convention in Chicago. With clout like that, it is no wonder Gov. James "Big Jim" Thompson (center) paid a visit to Słowik Hall, at 3200 North Milwaukee Avenue. (Courtesy Joe Jurek.)

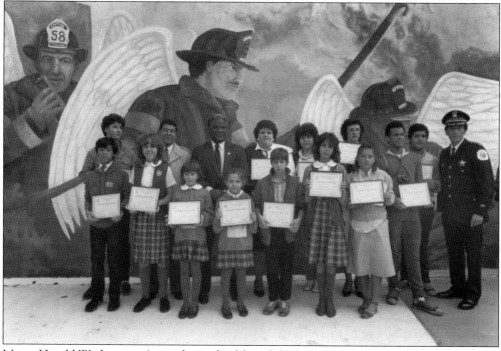

Mayor Harold Washington (second row, third from left) attends the dedication of Fireman's Park at Kimball and Diversey Avenues in 1985, which honors three firemen who were killed battling a nearby blaze in February of that year. This working-class neighborhood has long been short of green space, and this addition was welcomed by many in the community. Thanks to Alderman Rey Colón, a new plaza opposite the park is currently under construction, a result of the removal of a section of Woodard Street. (Courtesy Chicago Public Library, Special Collections and Preservation Division, HWAC 10-22-85.)

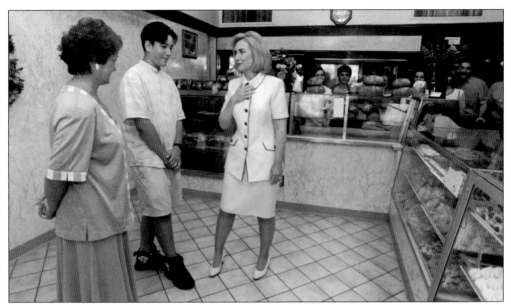

First Lady Hillary Clinton visits Pasieka Bakery in August 1996. Cheesecake from this Polish American institution was served in the White House during the term of Bill Clinton. In 2013, the Greater Avondale Chamber of Commerce, in conjunction with the Parish Council at St. Hyacinth Basilica, reached out to the former first lady to invite her for a return visit to Avondale during their parish carnival. While the offer was graciously declined, locals still hold out hope for a future visit. (Courtesy Mark Pasieka.)

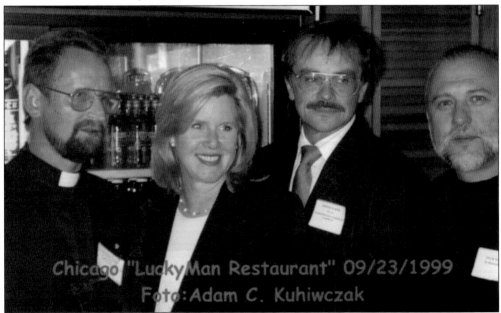

Tipper Gore (second from left) was a guest at Lucky Man Restaurant in 1999, accompanied by Pastor Michał Osuch of St. Hyacinth Basilica (left), Joseph Jurek (second from right), and Jack Oblaza (far right). The Lucky Man was a well-known Polish eatery at 3382 North Milwaukee Avenue. The owner retired and returned to Poland. The venue continues as a culinary hot spot, now as a Mexican restaurant, La Oaxaqueña. (Courtesy Adam C. Kuchiwczak.)

Five

FROM POLISH VILLAGE TO POLISH MECCA

The Polish Village, or Polska Osada, dates to the founding of St. Hyacinth in 1894. The community is comprised mainly of two parts. St. Hyacinth Basilica anchors Jackowo, the Polish name for the "Polish patch" that dominates Avondale's west end. This ethnic neighborhood is usually clumped together with the Polish district just north around St. Wenceslaus, or Wacławowo, as local Poles refer to it. The settlement later grew as the "Villa District," a small subdivision that Chicago journalist Mike Royko christened the "Polish Kenilworth," just north of Wacławowo. It took shape in Irving Park during the first two decades of the 20th century. The Polish Village soon came to dominate the vicinity.

The author of a *Chicago Tribune* piece published in 1913 described the area this way:

> On past Irving Park boulevard and into Avondale, where the names on the street signs make evident that this is a Polish neighborhood, "Ski" is the regular terminal, while the trim brick flats and shop buildings and the well kept, well paved side streets leading off from the avenue declare that these people are well to do and enterprising. Where Belmont Avenue cuts diagonally across Milwaukee Avenue there is a big holding of vacant land by a New York man, who is waiting to cash in on the movement increment built up by the busy immigration.

As Polish refugees made the area their first home in the New World, a distinct flowering of Polish arts and culture took place in Avondale. Here, Poles could freely express themselves without worrying about incurring the wrath of government censors or the threat of political repression. Through organizations such as the Polish American Congress, Pomost, and Freedom for Poland, the events and activities organized by Chicago's Polish community played a key role in shaping the chain of events that resulted in the collapse of the Communist government in Poland. A highly expressive and now-decaying mural in the McDonald's parking lot on Belmont Avenue just west of Pulaski Road, titled *Razem* ("Together"), combines Polish patriotic and folkloric motifs in mute testament to this bygone renaissance.

Avondale's connection to Chicago's Polonia has brought the area some notable visitors, including a future Polish pope and two presidents of Poland. Given that St. Hyacinth has served as a polling place where Polish citizens are able to vote in elections in their former homeland, it is not surprising that a steady stream of government officials and candidates from Poland have made campaign stops here, often full of drama and excitement.

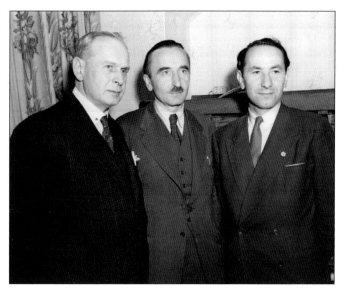

After his election as head of the Polish National Alliance, Karol Rozmarek relocated to Chicago, where the fraternal organization bought him a residence in the Belmont Gardens section of Avondale. His home became a hotbed of Polish American activism on behalf of the occupied motherland. Pictured here in Rozmarek's home are representatives of the Polish government in exile, which was based out of London, having come to confer with the leader of American Polonia. (Courtesy Charles Komosa.)

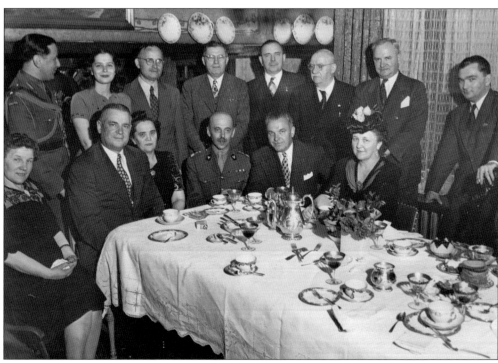

In the spirit of ethnic solidarity, Rozmarek's grandson Charles Komosa estimates that well over 7,000 Poles displaced as a result of World War II came through the Rozmarek residence in the course of a decade. As displaced persons arrived in the United States as refugees, the home earned its nickname as the "Hotel Rozmarek." Karol Rozmarek is seen here with General Tadeusz Bór-Komorowski, his family, and members of the Polish American Congress at his home in 1948. (Courtesy Charles Komosa.)

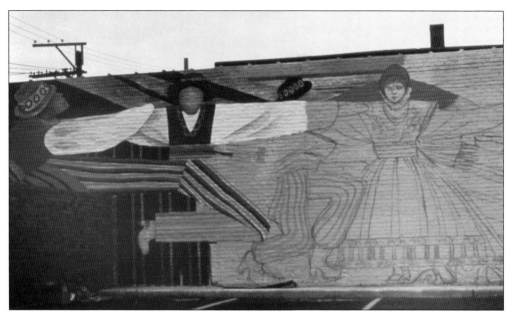

Completed in 1975, the *Razem* mural in the McDonald's parking lot at 4038 West Belmont Avenue was actually painted on the east wall of the former Maurice Lenell cookie factory (see page 28). (Courtesy Chicago Public Art Group.)

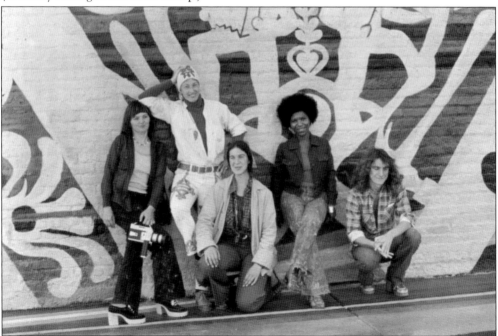

The lead artist on the mural was Caryl Yasko (second from left). Assisting Yasko were, from left to right, Celia Radek, Lucyna Radycki, Justine DeVan, and Jan Kokot. This work captured the vitality of the diverse art forms that were on display in Jackowo. Countless Polish artists were lured here by the possibility of creating without government censorship and the excitement of an American adventure, as well as the opportunity to gain monetarily on the trek. (Courtesy Chicago Public Arts Group.)

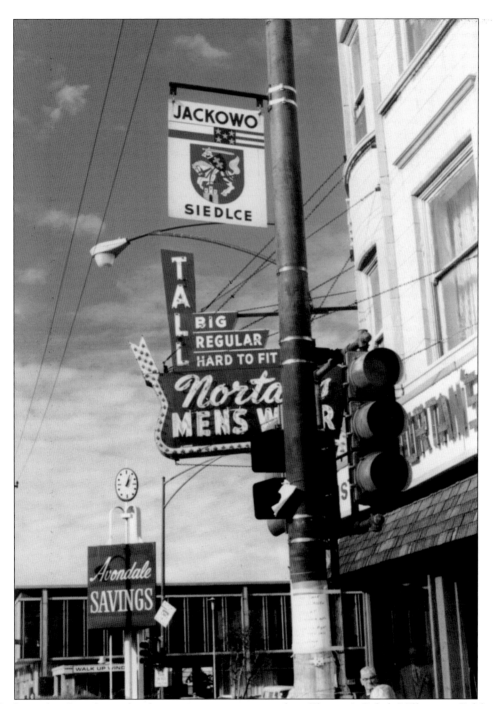

Jackowo has long been the dominant community within Chicago's Polish Village, or Polska Osada, overshadowing both Wacławowo and the Villa District. In the early 1980s, under Mayor Jane Byrne, 64 neighborhood identifiers with historic crests of Polish cities were installed along Milwaukee Avenue between Kostner and Kimball Avenues, a testament to the strong ties that bound the area to Poland. Their removal under Mayor Richard M. Daley is a loss that is still mourned by the Polish community. (Courtesy Jerzy "George" Skwarek.)

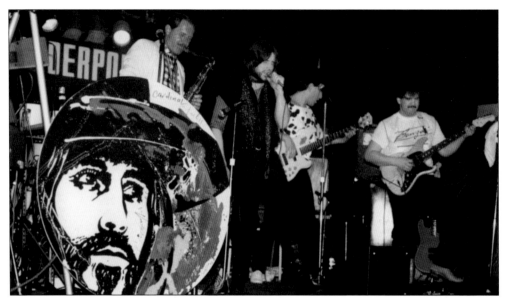

Czesław Niemen was a legend of Polish rock. Singing mostly in Polish, Niemen also performed in English. He famously introduced psychedelia to Poland, melding it with Slavic folk and patriotic motifs. Part of the matchless allure of the Polish Village for residents at the time was their good fortune to regularly socialize with Polish cultural superstars of the highest caliber. (Courtesy Jerzy "George" Skwarek.)

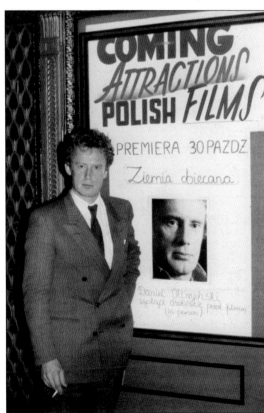

Polish actor Daniel Olbrychski is shown standing in front of a notice for the debut of his film *The Promised Land* in the lobby of the Milford Theatre. Olbrychski is known to most Americans for playing Russian spymaster Vassily Orlov in the movie *Salt* with Angelina Jolie. (Courtesy Jerzy "George" Skwarek.)

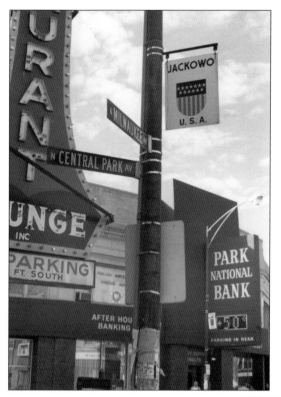

This 1983 photograph reveals a fragment of the iconic neon sign of the Orbit Restaurant at Central Park and Milwaukee Avenues, as well as a Jackowo sign. Opened by Tadeusz Kowalczyk in 1979, the Orbit was more than just a restaurant. But Kowalczyk would be undone by poor business decisions as well as an ill-fated marriage to Violetta Villas, a onetime Polish sex symbol, and the restaurant closed in the early 2000s. (Courtesy Jerzy "George" Skwarek.)

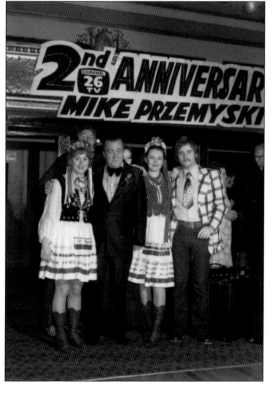

Shown here in the banquet hall of the Orbit Restaurant (the former Wonderland Ballroom) is Mike Przemyski (second from left), once a prominent local television personality on Channel 26. Przemyski, also a former radio personality, hosted the *Polish Morning Bells Polka* radio program in the 1960s on 1490 AM. (Courtesy Jerzy "George" Skwarek.)

Songstress Kalina Jędrusik starred in over 30 Polish films between 1958 and 1991. Notably, she performed duets with Violetta Villas in the United States during the late 1970s. Villas had been a Polish sex symbol in the 1960s and would later marry the "Mayor of Jackowo," Ted Kowalczyk, owner of the Orbit Restaurant. (Courtesy Jerzy "George" Skwarek.)

Polonia Bookstore was the literary pipeline connecting the socially diverse Polish communities of Chicago with literature in the Polish language. Hosting meetings, lively discussions, and poetry readings, the bookstore was also a vital outlet of information coming out of Poland for politically engaged Solidarity refugees. (Courtesy Polonia Bookstore.)

Education was also a part of Polish civic life. PUNO, or the Polish University in Exile, for a time had an outpost in Chicago. This institution of higher learning, founded during World War II, was based in London, the seat of the Polish government in exile. Pictured here are students enrolled in the programs located in the Pomost building at 3242 North Pulaski Road. (Courtesy Jerzy "George" Skwarek.)

Pomost ("Footbridge"), located at 3242 North Pulaski Road, was an important anticommunist organization whose origins were among students at the University of Illinois at Chicago. Notable members included Prof. Jan Magnus Kryński and acclaimed Polish-Jewish writer Leopold Tyrmand. Pomost systematically supported the democratic opposition in Poland, both financially and with material aid, shipping them relief packages, radio equipment, covert literature, underground printing equipment, and even polygraph machines. In America, it helped distribute independent writings published in Poland. (Courtesy Jacob Kaplan.)

The Polish Village was a hotbed of activity whose overriding goal was to abet the democratic opposition in Poland and to end Communist rule. Here, activists raise funds on Milwaukee Avenue in front of Staropolska Restaurant for a monument honoring Poles massacred by Stalin during World War II. Wojciech Seweryn, the main driver behind this monument, would tragically perish with Polish president Lech Kaczyński and 96 others in a plane crash in Smoleńsk, Russia, on April 10, 2010. (Courtesy Jerzy "George" Skwarek.)

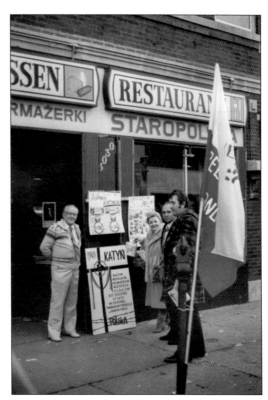

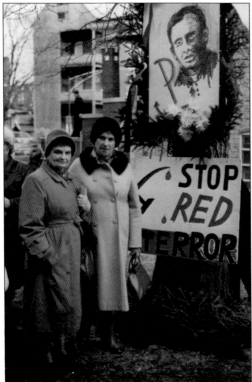

Jerzy Popiełuszko was a Polish priest and a vocal chaplain for the anti-Communist Solidarity trade union. He was murdered by the Communist secret police. A symbolic grave with a plaque for him by acclaimed artist Stefan Niedorezo still stands in The Garden of Memory next to St. Hyacinth Basilica. (Courtesy Jerzy "George" Skwarek.)

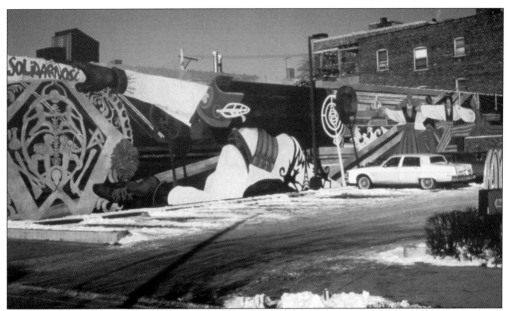

In 1982, artist Caryl Yasko's the *Razem* mural in the McDonald's parking lot at 4038 West Belmont Avenue was modified with the logo of Solidarity, or Solidarność. The addition of this anti-Communist Polish trade union's logo was a sign of support while the Communist regime imposed martial law to break up the movement and thwart its ideological opponents. (Courtesy James Prigoff.)

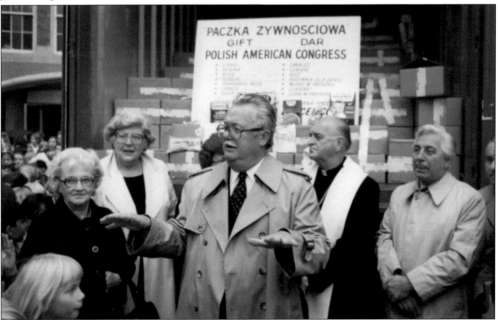

Aid from Polish Americans played a vital part in helping Poland survive during the economic and social perils of martial law imposed by the Communist regime. Here, PNA president Aloysius Mazewski (center), in the company of Alderman Roman Pucinski (far right), is directing a program to collect aid for Poland in the parking lot of St. Hyacinth Basilica. (Courtesy Jerzy "George" Skwarek.)

Bogusław Linda, a versatile actor most associated with his roles in Polish action films, is shown here during his visit to Chicago. Married to Polish model and photographer Lidia Popiel, Linda appeared in the Andrzej Wajda films *Man of Iron* and *Danton*, as well as Krzysztof Kieślowski's movie *Blind Chance*. This photograph was taken at Orbit Banquets, the successor to the Wonderland Ballroom, located at Central Park and Milwaukee Avenues. (Courtesy Jerzy "George" Skwarek.)

The visit of Pres. Lech Kaczyński to St. Hyacinth Basilica was a point of pride for the parish. Pictured here is Kaczyński (left) with Pastor Michał Osuch (right). St. Hyacinth parishioner and community activist Wojciech Seweryn, honored for his work in bringing about a monument to a Soviet massacre of Poles, would perish along with Kaczyński and everyone on the presidential plane that crashed on the morning of April 10, 2010, in Smoleńsk, Russia. (Courtesy St. Hyacinth Basilica.)

A bizarre intersection of the political worlds of two countries took place at St. Hyacinth Basilica. Shown here are two men, arguably at the height of their powers, who would eventually see their careers end in disgrace. Andrzej Lepper (left of center), Polish deputy prime minister as well as minister of agriculture and rural development, would commit suicide in 2011 after allegations of corruption and sex scandals crushed his political career. Gov. Rod Blagojevich (right of center) would end up being sentenced to 14 years in federal prison in 2011 after having been impeached and removed from office. (Courtesy Dariusz Lachowski.)

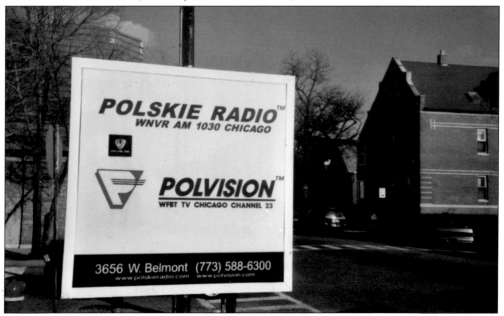

Polvision, located at 3656 West Belmont Avenue, broadcasts programming in Polish 24 hours a day, bringing news and content produced locally as well as in Poland. (Courtesy Dan Pogorzelski.)

Six

COME TOGETHER

Many of the same trends in 20th-century America's social and cultural landscape played out on a smaller scale in Avondale, impacting the way residents raised their families, spent their leisure time, and interacted with neighbors. After manufacturing and construction jobs in Avondale attracted immigrant populations to the area in the late 19th century, schools and parks were established to help nurture children of families who planted their roots in the area. Neighborhood taverns, once one of the most pervasive gathering places for working men, began a slow decline by the 1910s as advances in motion-picture technology spawned the development of neighborhood cinemas, first storefront nickelodeons and then larger theaters. Bowling alleys provided another venue for all-ages recreation, established at several locations in Avondale and peaking at mid-century. Various nightclubs, including the Milford Ballroom, Café Lura, Maryla Polonaise, and Europe at Night, supported local acts as well as performers from immigrants' old homelands.

By the close of the 20th century, bowling alleys, cinemas, and most neighborhood taverns had disappeared from Avondale. But, ever-adaptable residents have found new ways to come together across cultural and ethnic divides, most recently collaborating to beautify expressway and railway underpasses with gardens and colorful murals depicting life and new hope in Avondale.

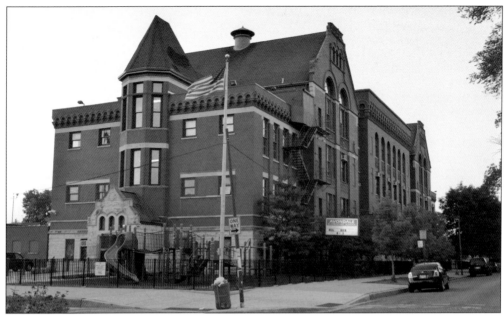

Following Jefferson Township's annexation to Chicago in 1889, infrastructure improvements came rapidly to Avondale. In 1893, German-born August Fiedler became the city's first chief architect for the board of education. Avondale School, at Sawyer and Wellington Avenues, was among his first designs during his tenure. Typical of his style, this school featured upper floors finished with pressed brick and round-topped windows. (Courtesy Mark Dobrzycki.)

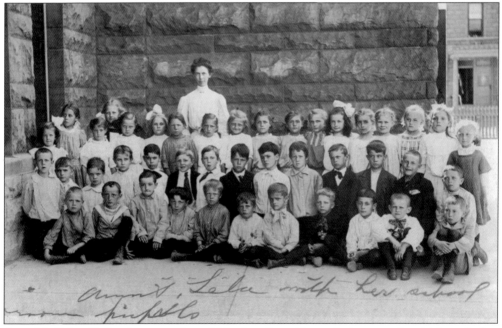

Avondale School helped support the neighborhood's rapid population growth, which peaked at over 38,000 by 1930. Like parks, public schools were a key element in the Progressive Movement's aim to integrate the diverse ethnic groups that called Chicago home. In this respect, Avondale School is no exception—a tradition it proudly continues today. (Courtesy Avondale School.)

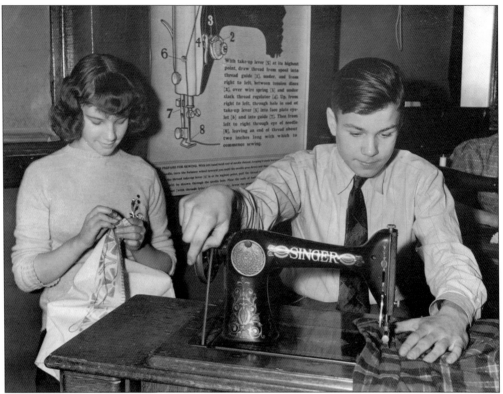

A 1931 *Chicago Tribune* article noted an increasing emphasis on shop work, household arts, and home economics in Chicago Public Schools based on the premise that children "should be taught to live more economic lives than their parents are now living." Pictured here is a sewing class at Avondale School. (Courtesy Avondale School.)

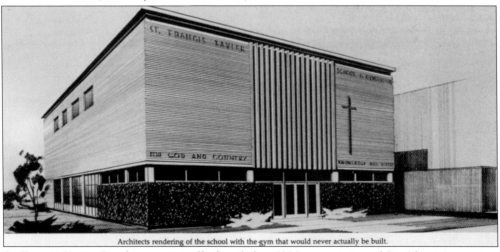

Architects rendering of the school with the gym that would never actually be built.

St. Francis Xavier Parish was originally founded in 1888 as a mission of St. Aloysius at a time when Avondale was still sparsely settled. A school building at 3045 North Francisco Avenue was constructed in 1906. St. Francis Xavier and St. Veronica were later merged into Resurrection Catholic Academy. This is an architect's rendering of the proposed St. Francis Xavier gym, which was never built. (Courtesy Resurrection Roman Catholic Church.)

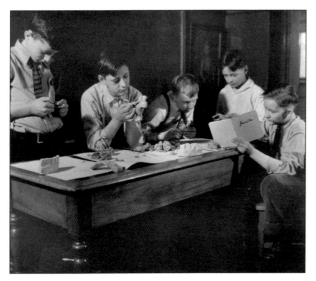

The construction of a railroad station and a post office near Belmont Avenue and Hammond (now Troy) Street contributed to population growth in Avondale along Belmont Avenue. The area east on Belmont toward the Chicago River became known as Bricktown, due to the abundance of clay pits and brick factories. In 1895, Linné School, named after the 18th-century Swedish botanist and zoologist Carl Linnaeus, was built on Sacramento Avenue just north of Belmont Avenue. This photograph shows a class at Linné in 1937. (Courtesy Carl Von Linné School.)

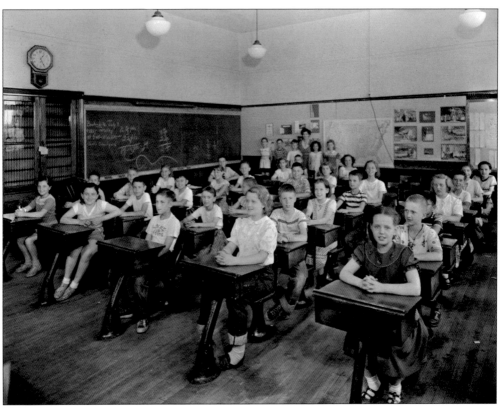

Residential growth in Bricktown was further spurred by the extension of the Belmont and California Avenue streetcars in the late 1890s. In 1904, Linné School was expanded to include an additional 12 classrooms as part of the school board's goal to "house the entire school population in its own buildings, and thus do away with the insanitary rented quarters," according to the *Chicago Tribune*. A 1953 class at Linné is seen here. (Courtesy Carl Von Linné School.)

The Ephpheta School for the Deaf was founded in 1884 and relocated to this building at Belmont and Crawford Avenues in 1898. The school focused on teaching domestic sciences, millinery, and dressmaking to girls and industrial and trade classes to boys. By 1951, this building was occupied by Madonna High School before being demolished in the early 1970s to make way for a grocery store. (Photograph by Ed Kall, courtesy Chicago History Museum, ICHi-68003.)

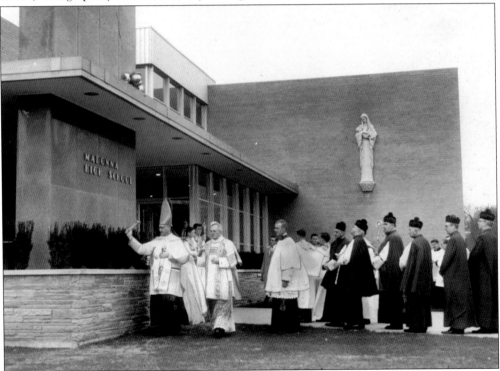

Founded as an all-girls' Catholic school in 1949, Madonna High School quickly outgrew its capacity at both its original location on Hamlin Avenue as well as at the site of the former Ephpheta School for the Deaf. Pictured here is the consecration of a new location at 4035 West Belmont Avenue. In 2001, the school closed due to declining enrollment, and it was demolished soon thereafter. (Courtesy Archdiocese of Chicago's Joseph Cardinal Bernardin Archives and Records Center.)

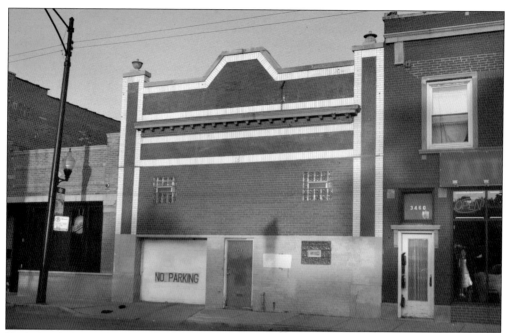

By the early 1910s, America had transformed into a predominantly urban industrial society, and motion pictures became the country's dominant form of mass entertainment. Converted storefronts known as nickelodeons began showing short films that drew large crowds from among immigrants and the working class. Unlike saloons, nickelodeons included significant numbers of women and children in attendance. Shown here is the former Community Theatre at 3458 North Pulaski Road, one of Avondale's many nickelodeons. (Courtesy Mark Dobrzycki.)

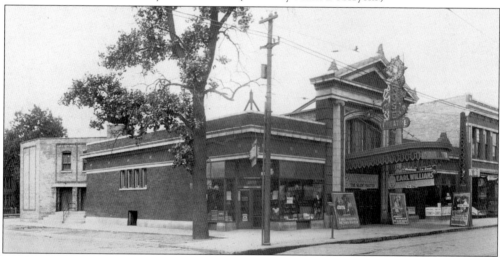

By the mid-1910s, nickelodeons were beginning to be replaced by larger theaters. In 1914, the 700-seat Rose Theatre opened at Milwaukee Avenue and Wolfram Street. It is pictured here in 1917. The theater enjoyed a successful run for a few decades. Several factors contributed to the decline of independent theaters, including suburbanization, international competition, and legal battles between independent cinema operators and large theater chains. Later renamed the Dale and then the Round-Up, the Rose Theatre was closed by the early 1950s and demolished in 2009. (Photograph by Charles E. Barker, courtesy Chicago History Museum, ICHi-68002.)

The Milford Theatre, pictured in the background in 1922, was named after the cross streets of Milwaukee Avenue and Crawford Avenue (now Pulaski Road). Built in 1917 and seating 1,175, this movie palace was initially run on the Ascher Brothers circuit and featured silent movies, a theater organ, and an adjacent ballroom. While Avondale's remaining theaters had closed by the early 1950s, the Milford was picked up by the H&E Balaban circuit and survived for several more decades. (Photograph by Chicago Daily News, Inc., courtesy Chicago History Museum, DN-0074823.)

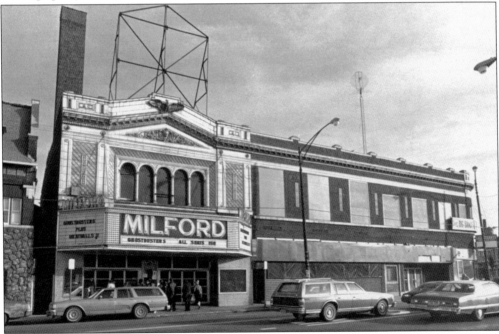

Adapting to changing neighborhood demographics, the Milford featured Polish films in the 1960s and 1970s before transitioning to the second-run market by offering 60¢ admission and surviving primarily on revenue from popcorn and candy sales. This photograph shows the Milford in 1984. In the mid-1980s, it tested the Spanish-language market before closing its doors for good in 1990. Just a few years later, the building caught on fire and was demolished in 1994. (Photograph by John McCarthy, courtesy Chicago History Museum, ICHi-25419.)

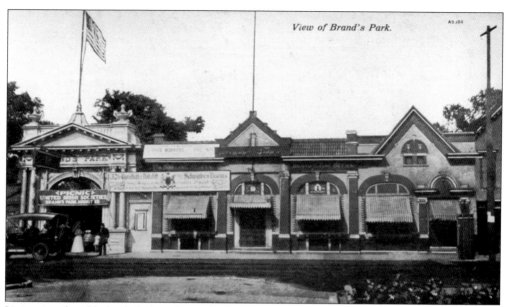

View of Brand's Park.

Living in a humble bachelor's pad atop his brewery on the west side of Elston Avenue in Logan Square, Virgil Brand turned a property on the east side of Elston Avenue in Avondale into an extravagant picnic grove around the turn of the 20th century. It featured a beer garden, a bowling alley (pictured), hobbyhorses, a dancing pavilion, a shooting gallery, photo booths, a merry-go-round, a fruit column, and a restaurant tent. (Courtesy Lake County [IL] Discovery Museum, Curt Teich Postcard Archives.)

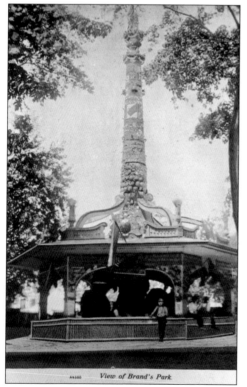

View of Brand's Park.

The fruit column in Brand's beer garden was likely a tribute to the famous fruit column of Stuttgart, Germany. In 1815, the eruption of Mount Tambora in Indonesia cast dust particles across Europe, leading to crop failure and famine. In 1918, King Wilhelm ordered the construction of a bowl of fruits atop a high pillar as a symbol of thanksgiving for an emergency grain shipment from Wilhelm's brother, Czar Nicholas of Russia. (Courtesy Lake County [IL] Discovery Museum, Curt Teich Postcard Archives.)

This replica of a northern German *hallenhaus* once stood at the edge of Brand's beer garden. The inscription above the doorway reads, *"Kehr in Du möder Wanderer un stärke diene Glieder,"* which translates to "stop in you tired traveler and strengthen your limbs." The gable features a wooden horse head, an adornment typical of northern Germany, a region of good, flat farmland similar to the American Midwest. (Courtesy Lake County [IL] Discovery Museum, Curt Teich Postcard Archives.)

This is one of four bars in Brand's picnic grove. In the late 1910s, after the park closed, Avondale residents began petitioning the River Park District to purchase the site. By 1928, the land was acquired, and construction began on recreational facilities, including a playground, horseshoe field, tennis court, and an athletic field flooded for ice-skating in the winter. The Chicago Park District took over Brand's Park in 1934. (Courtesy Lake County [IL] Discovery Museum, Curt Teich Postcard Archives.)

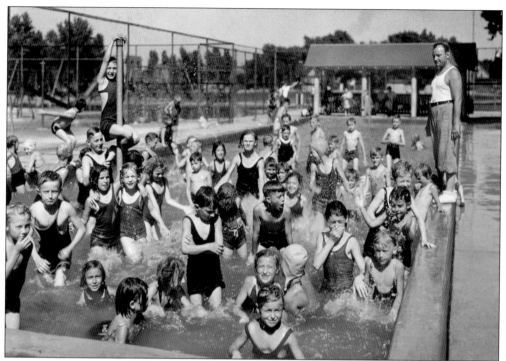

To accommodate the ongoing residential construction boom in Avondale in the 1920s, the Irving Park District commissioned the development of Avondale Park in 1929. Originally a five-acre park, it eventually included a playfield, sandbox, tennis courts, and the wading pool pictured here. Architect Clarence Hatzfeld designed a brick field house, which still stands today. (Courtesy Chicago Park District Special Collections.)

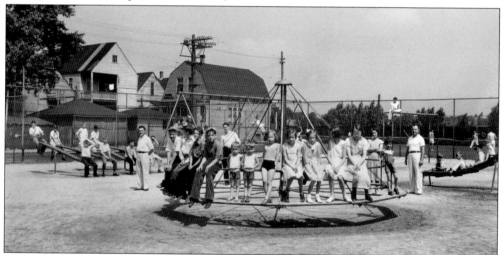

In 1959, the construction of the Northwest (Kennedy) Expressway reduced the footprint of Avondale Park to just over one acre, resulting in the elimination of the playfield, tennis courts, and roundabout (pictured). An overhead view of the area reveals that the expressway veers sharply off its otherwise straight northwesterly course to run along the park, reputedly in an effort to save industrial buildings along Avondale Avenue. (Courtesy Chicago Park District Special Collections.)

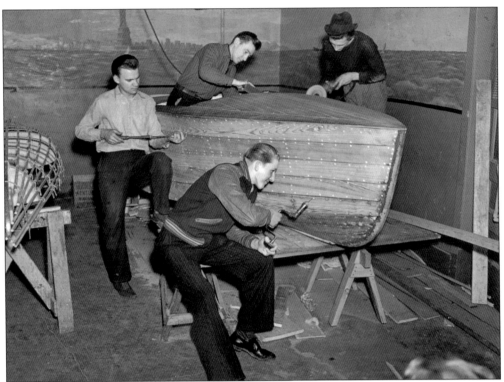

Named after Tadeusz Kościuszko, a Polish war hero who also fought with Americans in the Revolutionary War, Kosciuszko Park was dedicated in 1916 by the Northwest Park District as part of a goal to provide one park per 10 square miles within its jurisdiction. Located in the historic "Polish patch" of Jackowo, the park features a Tudor Revival field house. This 1940 photograph shows a boat shop at the park. (Courtesy Chicago Park District Special Collections.)

This 1964 photograph shows the skating lot in front of the Kosciuszko Park field house. Though skating rinks are scarce today, close to 200 skating ponds or lots were known to have been operating in the city in the late 1930s. Such skating lots were created by flooding playfields, courts, and lawns. (Courtesy Chicago Park District Special Collections.)

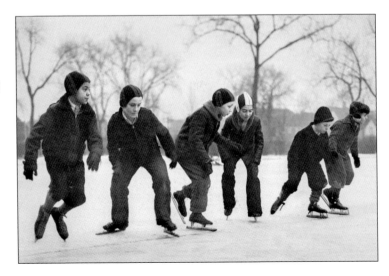

Creative and formal dramas have long been a key offering among the Chicago Park District's many free programs. Shown here is a 1963 production at Kosciuszko Park. (Courtesy Chicago Park District Special Collections.)

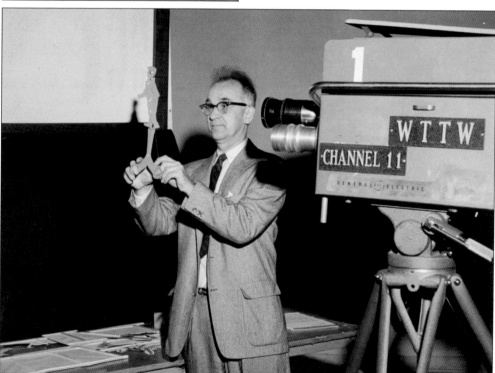

Pictured here filming a special for WTTW at Kosciuszko Park, Hans Schmidt taught puppetry to children for the Chicago Park District from 1958 to 1974. Schmidt initially developed an interest in puppetry as a thrifty means of teaching makeup and scenery for stage theater during the Depression before eventually developing a preference for puppetry. He said, "There are no inhibitions on the part of the performers, because they can hide." (Courtesy Chicago Park District Special Collections.)

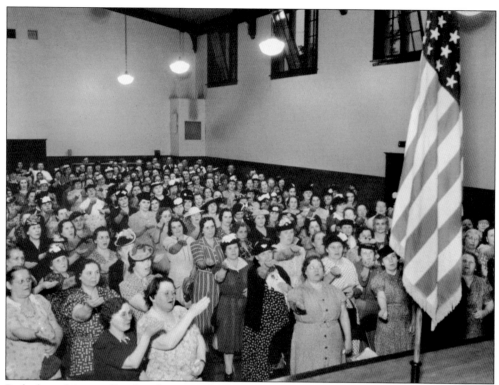

Parks have historically played a central role in assimilating immigrants to the United States. Americanization programs were once typical across the city, and after World War II, Kosciuszko Park was one of a number of facilities that held English-language and citizenship classes specifically for the large influx of "displaced persons," political refugees that had become stateless after the Soviets occupied Eastern Europe. (Courtesy Chicago Park District Special Collections.)

Following World War II, the Bureau of Parks and Recreation created several small parks across the city. One of these was Sacramento Park, named after Sacramento Avenue. After the land was purchased in 1950, the park was developed to include playground equipment, a basketball court, and a ball field. Pictured here are hobbyhorse swings, which were once common across the city. (Courtesy Chicago Park District Special Collections.)

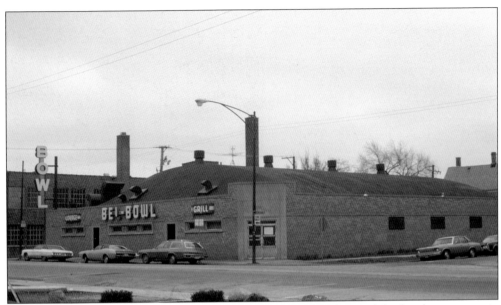

Until the middle of the 20th century, Chicago was considered one of the bowling centers in America. Avondale had its share of alleys, including the Bel-Bowl, which stood at the corner of Belmont and Spaulding Avenues for several decades. This alley hosted a variety of tournaments, including the Hall-Roto-Central Athletic Association handicap tournament, the Allied Printing Trades bowling tournament, and events for the American Blind Bowling Association. (Courtesy John R. Schmidt.)

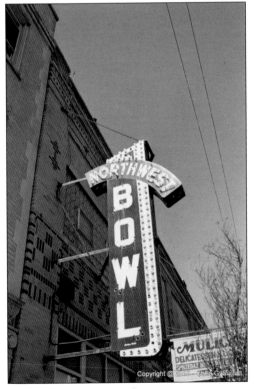

Opened in the 1920s, Northwest Bowl at Milwaukee Avenue and Haussen Court was originally known as the John Gorny Jr. Billiard Room. It continued operating until at least the 1980s. While interest in bowling has declined nationwide since its mid-century peak, alleys such as Diversey Bowl and Waveland Bowl remain accessible just outside Avondale's boundaries. (Courtesy Carla G. Surrat.)

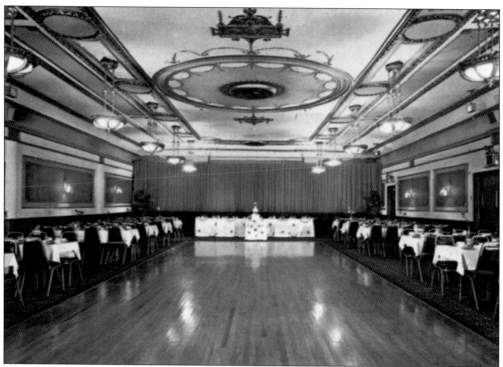

For several decades, the Wonderland Ballroom served as a venue for banquets and folk dances in Avondale's Polish community. The ballroom was located at the southwest corner of Milwaukee and Central Park Avenues in a historically significant 1916 building designed by noted Jewish architect Henry L. Newhouse. The building later housed the Orbit Restaurant. (Courtesy Lake County [IL] Discovery Museum, Curt Teich Postcard Archives.)

This building at Elston and Wellington Avenues was once home to Europe at Night, a world-music club and gathering place for immigrants and refugees from around the world. The club's proprietor, Nada Spasojević, was a refugee from Serbia and an internationally renowned singer, lyricist, and composer. A scholarship at Northeastern University has been established in her honor. (Courtesy Rob Reid.)

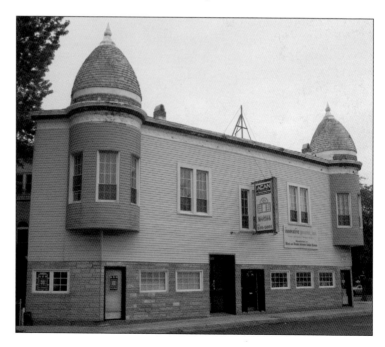

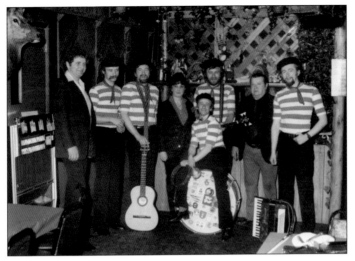

Maryla Polonaise, on Milwaukee Avenue just south of Belmont Avenue, once hosted famous Polish acts such as Czerwone Gitary, Eleni Tzoka, and Skaldowie. In the 1980s, the venue provided a great opportunity for visiting bands, covering their airfare and providing an apartment above the venue for as long as they could draw crowds. Kapela Gdanska is pictured here. (Courtesy Jerzy "George" Skwarek.)

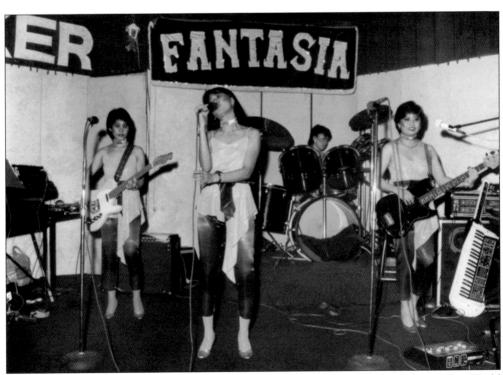

The intertwined relationship between Filipinos and Poles in Chicago goes back to just after World War I, when a sizable group of Filipino men married the Polish widows who lost their husbands in General Haller's "Blue Army." To this day, Avondale has a thriving Filipino Community. Many of its residents worship in the Avondale churches founded by Polish immigrants. Cross-cultural contact also extended into the domain of entertainment, as illustrated by this Filipino band performing at Maryla Polonaise. (Courtesy Jerzy "George" Skwarek.)

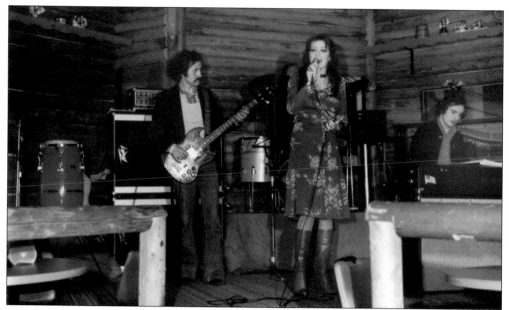

Anna Jantar, a promising young Polish singer who collaborated with her composer husband, Jarosław Kukulski, is pictured here at Maryla Polonaise. Her career was cut short at the age of 29, when she died in a plane crash while returning home to Poland. Her daughter Natalia Kukulska achieved fame as a child actress in Poland. (Courtesy Jerzy "George" Skwarek.)

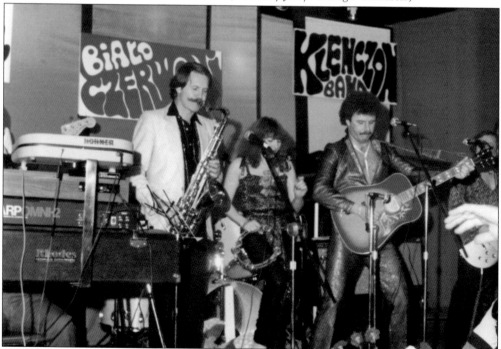

Krzysztof Krawczyk (right), vocalist and cofounder of the popular Polish band Trubadurzy, performs at the Milford Ballroom. One of the banners in the background pays tribute to another famous Polish songwriter, Kryzstof Klenczon, who died after being seriously injured by a drunk driver on the way back from the Milford. (Courtesy Jerzy "George" Skwarek.)

With origins in Eastern Europe, the polka as it is known today is an American creation, blending the musical traditions of both the Old and New Worlds. About polka music, Laurie Gomulka-Palozzolo wrote, "Within each of us there is a longing to reach back to that place from whence we came. It is perhaps the folk songs and dances of our native lands that best represent and forever bond us with that place, and which respond to our need to find the thread that connects us to the fabric of our lineage. For those of Eastern European descent, it is perhaps polka music that is the most passionate and emotional link to that place we know as home." Podlasie Club at 2918 North Central Park Avenue still features Polka dancing every Saturday night. (Courtesy Rob Reid.)

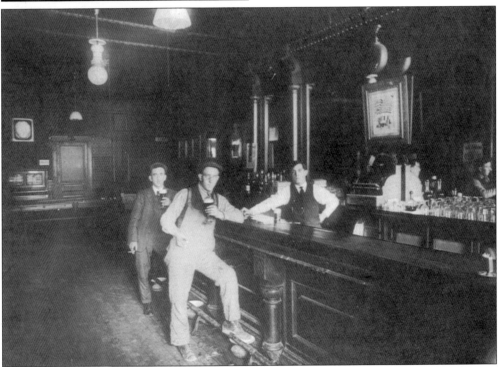

Since the early 1970s, Frank and Mary Stark have run a neighborhood tavern at Elston Avenue and George Street known for serving up home cooking for lunch on weekdays. The site has functioned as a tavern dating back to the Prohibition era, when this photograph was taken. (Courtesy Frank and Mary Stark.)

In the late 1930s and through the 1940s, the site of Frank and Mary's Tavern was known as Jeanette's Tavern. By this time, Germans and Scandinavians had largely moved out of the area, replaced by Eastern European immigrants. The signs at right, in Polish and English, read "Our beer makes you feel single and see double." (Courtesy Frank and Mary Stark.)

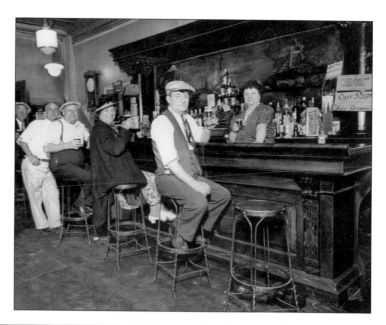

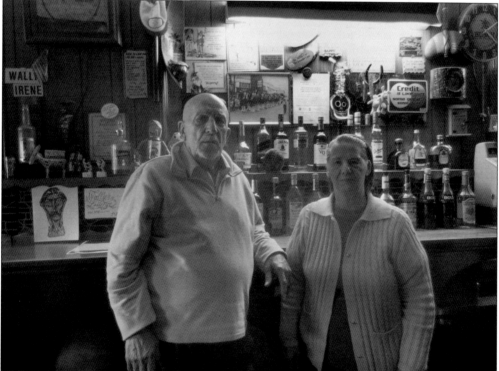

Neighborhood taverns have been in gradual decline since the early 20th century due to competition from movie theaters, bowling alleys, and other entertainment venues, many of which have their own liquor licenses. This decline has accelerated in recent decades due to advances in home entertainment and the difficult process of obtaining a liquor license. Pictured here are Wally and Irene Kozinski in Wally's Lounge at 3017 West Belmont Avenue. Established in 1978, it was sold in 2014 and remains a tavern now known as Reed's Local. (Courtesy Rob Reid.)

In recent years, groups of dedicated volunteers have helped improve the once-dreary landscape of expressway and rail underpasses in Avondale. Mexican artist Rafael López volunteered to design this mural at Addison Street and Avondale Avenue, leading a team of artists and volunteers to complete the work. "A mural always tells you that this is a community that is alive and vibrant, that is present," said López. Since completion of the mural in 2012, a community garden and pathway of engraved bricks have been added to the site. (Courtesy Mark Dobrzycki.)

A painting class from Northeastern Illinois University helped transform another bleak viaduct, at Diversey and Talman Avenues, in 2013. The mural, titled *The Two Fridas*, plays on the neighborhood's cultural geography as the place where Eastern Europe meets Latin America. (Courtesy Mark Dobrzycki.)

Seven

An Expressway
Runs through It

As Avondale and the Northwest Side of Chicago grew in the early 20th century, so did traffic congestion. Main arterials like Milwaukee and Elston Avenues were clogged, not just with local traffic, but also with long-distance travelers making their way to and through the city. City planners identified this congestion as a major issue to be alleviated. As early as the 1920s, plans started referring to an "Avondale Avenue Improvement." The idea was to create a limited-access highway roughly paralleling Avondale Avenue, which in turn parallels the Chicago & North Western Railway. This plan would eventually morph into the present-day Kennedy Expressway, with its route directed through the heart of Avondale.

When construction on the Northwest Expressway began in the late 1950s, it was heralded as a major improvement that would breathe new life and vitality into the neighborhoods it ran through. Little was written about the people it would directly affect, such as families in Avondale who would have their homes demolished for the new road. The new expressway would indeed have major effects. Not just homes, but factories and churches in the pathway of the road were demolished. People and businesses had to relocate. Major roads were closed for months at a time for construction. It was a serious disruption for Avondale, as well as one of the largest infrastructure projects the neighborhood has ever seen, before or since.

Once construction was completed and the expressway opened to traffic in 1960, it had permanently altered the character of much of Avondale. Streets such as Kimball Avenue that had been relatively sleepy thoroughfares were turned into major traffic and commercial corridors practically overnight with the addition of expressway interchanges. Intersections like Belmont and Kimball Avenues near the expressway were widened and transformed to handle additional traffic flow. Despite the disruptions and changes, Avondale became easier to access with the new expressway. Like other controversial urban developments, the Kennedy Expressway has been a double-edged sword for the neighborhood.

The expressway brought irrevocable change to Avondale. This photograph looks north on Kimball Avenue at Melrose Street in 1954, shortly before construction began on the Northwest Expressway. This view is virtually unrecognizable today; the bungalows at left were demolished for the Kimball off-ramp. (Courtesy Chicago Park District Special Collections.)

This view shows the northwest corner of Kimball Avenue and School Street in 1954, shortly before expressway construction began. All of the buildings on the left would be obliterated for the expressway. Here, Kimball appears as almost a sleepy residential street. The coming of the expressway would permanently change its character into a major traffic corridor. (Courtesy Chicago Park District Special Collections.)

Until the expressway opened in 1960, Kimball Avenue north of Belmont Avenue was a relatively lightly trafficked street, as this view looking north in 1954 demonstrates. I.S. Berlin Press is visible at right. All of the houses at left would later be demolished for a shopping center, and Kimball Avenue would be widened, reflecting how the coming of the expressway changed traffic flow and development patterns on surrounding surface streets. (Courtesy Chicago Park District Special Collections.)

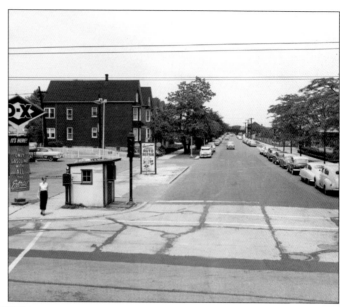

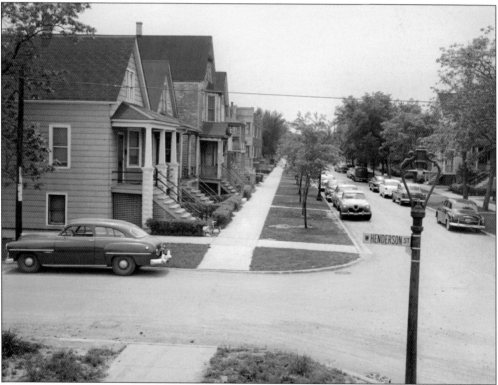

This 1954 view looks south on Drake Avenue from Henderson Street. While this particular block of Drake was not demolished for expressway construction, the expressway runs directly behind where the photographer is standing. The expressway drastically changed the character of this section of Avondale, and its construction reflected changing transportation trends. Note the number of cars parked on the street; clearly, the automobile was becoming a major mode of transportation for Avondale residents. (Courtesy Chicago Park District Special Collections.)

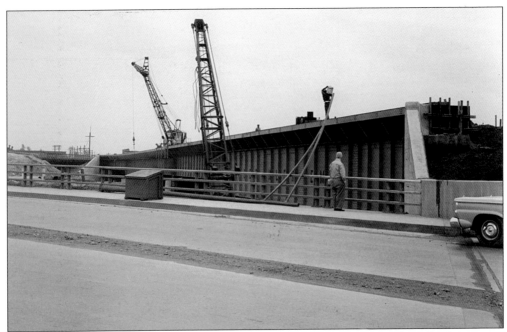

Construction of the Northwest Expressway was one of the largest and most complicated infrastructure projects ever seen on the Northwest Side. Here, the Chicago & North Western Railway is being bridged over the new expressway at Addison Street in the late 1950s without interrupting service on the railroad line. (Courtesy Aerial Surveys Section, Illinois Department of Transportation.)

The expressway cut wide swaths through former residential and industrial land. Here, excavation for a depressed portion of the Northwest Expressway is seen in this late-1950s photograph looking south toward Addison Street. (Courtesy Aerial Surveys Section, Illinois Department of Transportation.)

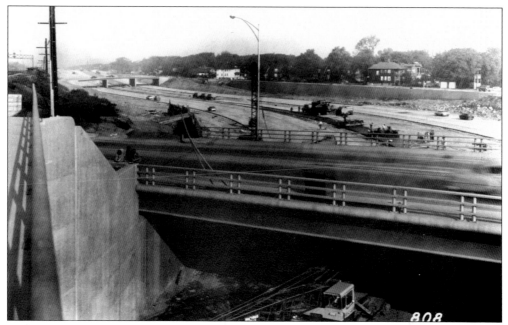

In this view looking north from the Chicago & North Western Railway bridge in the late 1950s, the expressway has been partially opened to traffic, though construction has not yet been completed. (Courtesy Aerial Surveys Section, Illinois Department of Transportation.)

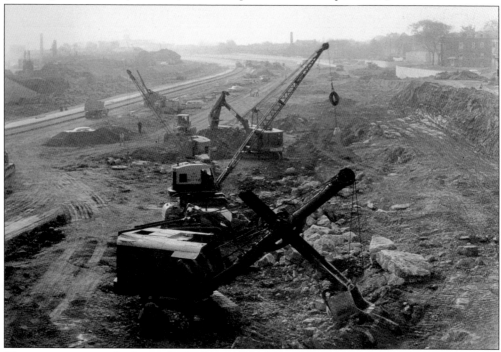

This sweeping view looks south into Avondale from Addison Street in the late 1950s. The expressway is being excavated and graded. The change from a depressed to an elevated roadway at Kimball Avenue can be seen here. The massive effect of the expressway on the surrounding area is clearly evident. (Courtesy Aerial Surveys Section, Illinois Department of Transportation.)

Most of the Northwest Expressway was built as an elevated structure through Avondale. This 1959 photograph shows construction proceeding at Belmont and Kedzie Avenues looking west on Belmont. (Courtesy Special Collections & University Archives, University of Illinois at Chicago Library, James S. Parker Collection, JPCC_01_0123_1475_0002.)

Expressway construction often resulted in long closures of surface streets, such as Belmont Avenue, seen as basically a dirt road in this photograph looking east toward Kedzie Avenue in 1959. Angie's Grill and its classic neon sign are now long gone. (Courtesy Special Collections & University Archives, University of Illinois at Chicago Library, James S. Parker Collection, JPCC_01_0123_1475_0005.)

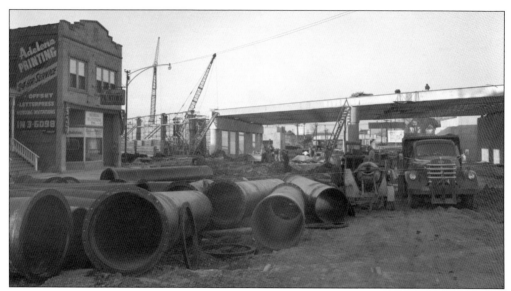

Around the corner, this view looks back north on Kedzie Avenue toward Belmont Avenue in 1959. Drainage improvements were a major component of expressway construction, as this photograph illustrates. The printing company at left is gone, but the building remains. (Courtesy Special Collections & University Archives, University of Illinois at Chicago Library, James S. Parker Collection, JPCC_01_0123_1475_0008.)

Expressway construction sometimes left behind excess land that was not needed for the roadway. To find solutions for this land, the Expressway Property Development Plan was commissioned by the State of Illinois and City of Chicago. Some of this land would be turned into pocket parks and playgrounds, such as Grape Park (pictured), developed in 1970 at 2850 North Avondale Avenue. (Courtesy Chicago Park District Special Collections.)

Church buildings were sometimes victims of expressway construction. This is the former St. Nicolai Evangelical Lutheran Church. Founded in 1889, this building was erected in 1916 at Albany Avenue and Barry Street. It is shown during a wedding in 1946. The church was demolished in 1957 for the Northwest Expressway, and the congregation was relocated to a new, modernist structure at 3000 North Kedzie Avenue (see page 48). (Courtesy Chicago Public Library, Sulzer Regional Library, HDG 2.79.)

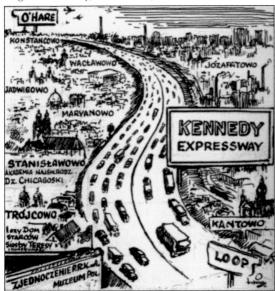

This cartoon, drawn by Walter Krawiec, criticizes the expressway for endangering Polish churches and dividing neighborhoods along the way, including St. Wenceslaus in Avondale (Wacławowo). While none of these churches were demolished for construction of the road, the expressway did divide many of these communities. (Courtesy *Polish Daily News*.)

Eight

AVONDALE'S LOST WONDER

Many Chicagoans who grew up on the Northwest Side have fond memories of the Olson Rug Park and Waterfall. Walter E. Olson built the 22-acre park, featuring a 35-foot waterfall, next to his rug-manufacturing mill at Diversey Avenue and Pulaski Road (then named Crawford Avenue). Olson, who owned a vacation home in Little St. Germaine, Wisconsin, wanted to "transplant some of the Wisconsin out-of-doors spirit to the then somewhat drab factory grounds." In addition to the waterfall, the park featured an elaborately landscaped rock garden, a bird sanctuary featuring ducks, swans and peacocks, and a hotdog stand.

The opening of Olson Park took place in 1935, on the 100th anniversary of the expulsion of Native American tribes from Illinois across the Mississippi River, and included a symbolic gesture deeding back the area of the park to America's First Peoples. Artifacts such as a birch-bark canoe and a totem pole were permanent installations at the park, and performances of actual Native American tribal dances were sometimes featured. Although the factory buildings still stand, Olson Park is gone. The properties were sold to Marshall Field's, which razed the park in 1978 in order to expand its parking lot.

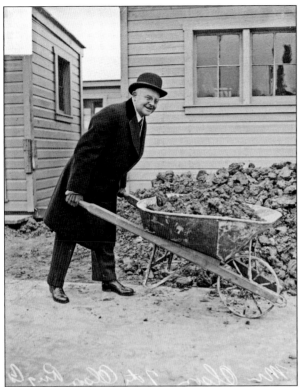

Walter E. Olson, president of Olson Rug Company, poses with a wheelbarrow at a ground-breaking. (Photograph by Hedrich-Blessing, courtesy Chicago History Museum, HB-02781.)

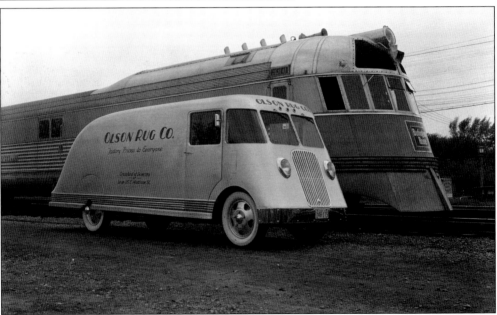

In 1935, the Olson Rug Company unveiled its first "streamliner" delivery truck, seen here next to the famous Burlington Route Zephyr train. The sleek, aerodynamic truck was built by General Body Company, at 2838 North Elston Avenue. The company is better known for designing the Oscar Meyer Weinermobile. (Photograph by Chicago Daily News, Inc., courtesy Chicago History Museum, DN-0088030.)

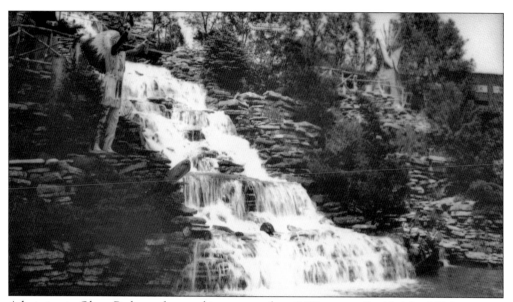

Admission to Olson Park was free, and it was open from 8:00 a.m. until midnight, 365 days a year. This 35-foot waterfall was lit with colorful lights after sunset, making the park a popular evening attraction. (Courtesy Northwest Chicago Historical Society.)

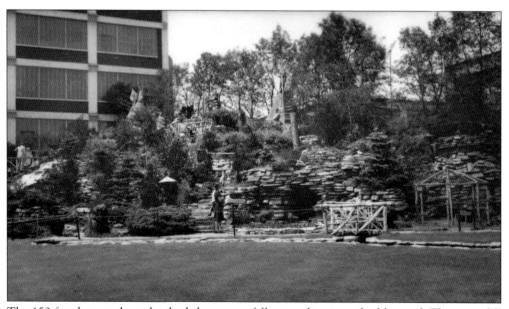

The 150-foot-long rock garden had three waterfalls cascading into the lily pond. This waterfall and the surrounding park supposedly attracted up to half a million visitors per year at one time. (Courtesy Northwest Chicago Historical Society.)

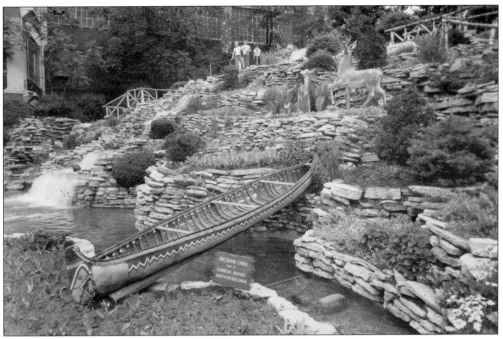

Pictured here in 1963 is a birch-bark canoe made by Flambeau Indians of northern Wisconsin. In addition to artificial deer, the park boasted a "bird sanctuary" with ducks, swans, and peacocks. (Courtesy Chicago Transit Authority.)

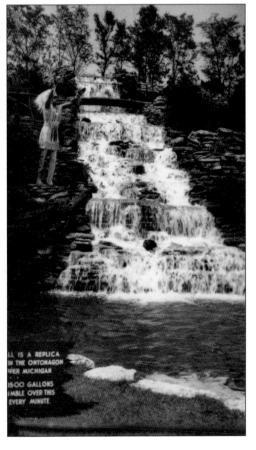

The Olson Waterfall, flowing at 15,000 gallons per minute, was a replica of waterfalls found in Ontonagon County in Michigan's Upper Peninsula. (Courtesy Northwest Chicago Historical Society.)

Although this particular Sioux warrior was inanimate, for a time Olson Park featured live performances by Chief Thundercloud of the Ottawa tribe. He entertained visitors with "Indian songs and tribal ritual." (Courtesy Northwest Chicago Historical Society.)

Pictured here is an "Indian tepee made and used on western plains by Chief White Cloud Sioux Indian." In addition to a permanent display of Native American objects, visitors looked forward to a fall tableau inspired by John T. McCutcheon's nostalgic cartoon "Injun Summer," which was reprinted every year in the *Chicago Tribune*. (Courtesy Northwest Chicago Historical Society.)

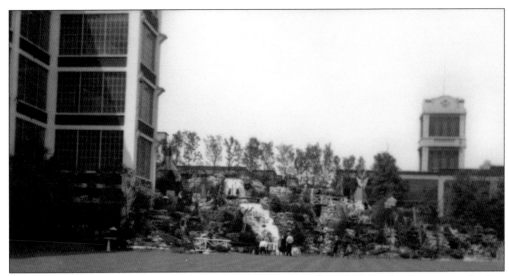

While developing Olson Park, Walter Olson personally selected rocks, birch trees, and other landscape features and loaded them onto a truck in Wisconsin. The result, when viewed from the sixth floor of the factory building, was once described as a giant rug. (Courtesy Northwest Chicago Historical Society.)

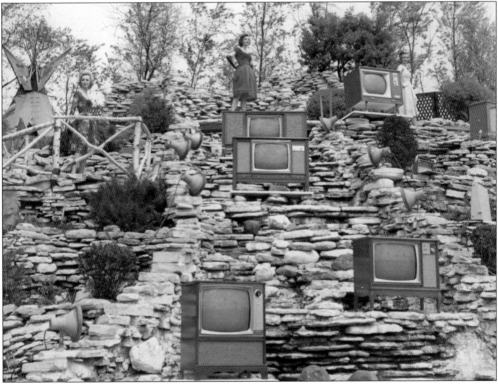

Chuck Zornig, who founded the Producers Corporation of America, shot an advertisement for Admiral Televisions with these models at the Olson Waterfall in 1964. A man of many talents, Zornig composed the music for the original Miller High Life theme song, an achievement that put him on the map in Chicago production. (Courtesy Chuck Zornig.)

Nine

GETTING AROUND

In a dense and sprawling city like Chicago, effective transportation is paramount. The need to get to work, to school, downtown, or to the movie palace precipitated the need for urban transit systems, and Avondale was no exception to this trend. Avondale has seen numerous forms of transportation during its existence.

Chicago has always been defined by its grid and by the streetcar lines that followed it. Avondale streets like Belmont, Crawford (later Pulaski Road), and Milwaukee Avenues were served by electric streetcar from the late 19th century onward. Trolley wires ran above major Avondale streets. These streetcar lines were later replaced by buses in the Chicago Transit Authority era, often first of the electric variety and then diesel. Finally, the coming of rapid transit affected Avondale. The Kennedy Rapid Transit Extension was built in a subway under Kimball Avenue. Its construction greatly disrupted everyday life in the area during the late 1960s. When the line opened in 1970, it made Avondale easier to access from the Loop and provided a new means of transportation to the community.

Beginning in the early 20th century, the automobile quickly became a very popular method of transportation throughout Chicago. Its popularity resulted in the construction of the present-day Kennedy Expressway, as discussed in chapter seven. But to this day, public transportation is a popular means of getting around Avondale, and many of the surface transit routes in the area still trace their history to earlier forms of transportation.

Chicago once had the largest streetcar system in the world. Between 1895 and 1949, electric streetcars plied Belmont Avenue through Avondale. Used to get to work, for pleasure trips, and for everything in between, the streetcars were a staple of the neighborhood. This Belmont Avenue streetcar is heading west near Kedzie Avenue in front of the former Klein Tools factory in 1948. Streetcars would disappear from Belmont Avenue a year later, and this whole area would be demolished for expressway construction by the late 1950s. (Courtesy Chicago Transit Authority.)

This Belmont Avenue trolleybus heads west at nearly the same location as the photograph above, but looking south across the street, in 1967. The Kennedy Expressway had opened just seven years earlier. The former Belmont Bowl is seen at right, as well Reliance Typesetting, another reflection of Chicago's status as a printing giant. Both buildings are long gone. (Courtesy the Scalzo Collection.)

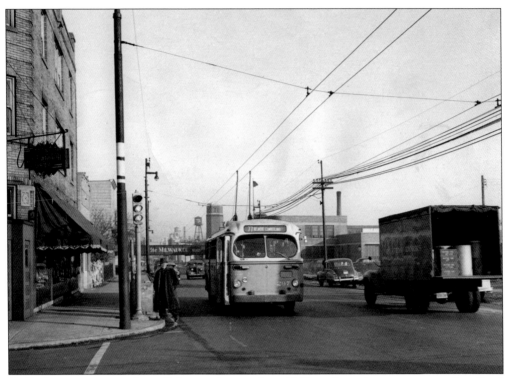

Trolleybuses were a staple on Belmont Avenue from 1949 until service was converted to diesel buses in 1973. The overhead wires were a common sight in Avondale. This photograph, taken between 1949 and 1952, shows a Belmont trolleybus heading west at Kostner Avenue. The unique tower of the Mercoid Controls (originally Sewell-Clapp Envelope) factory is seen beyond the bus. (Courtesy Chicago Transit Authority.)

Chicago Motor Coach (and later, Chicago Transit Authority) trolleybuses plied Diversey Avenue between 1930 and 1955. This 1930 photograph, taken shortly after service began, shows a Diversey trolleybus heading west across Crawford Avenue (later Pulaski Road), past the Olson Rug factory, built in 1926. The famous Olson Waterfall (see chapter eight) had not yet been constructed. (Courtesy Chicago Transit Authority.)

The Pulaski Road (formerly Crawford Avenue) streetcar route was converted to electric trolleybuses in 1951. Here, a trolleybus heads south on Pulaski Road past the Olson Waterfall in 1963. The route was converted to diesel buses in 1973, when the last trolleybus routes were phased out. (Courtesy the Scalzo Collection.)

The Kedzie-California streetcar route was converted to trolleybus in 1955. In 1967, this California route trolleybus heads north on California Avenue at Roscoe Street past the present-day WMS Industries complex. This route would be converted to diesel buses only two years later in 1969. (Courtesy the Scalzo Collection.)

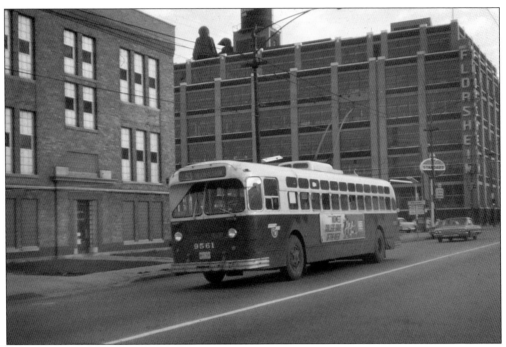

Transit was often used to get to work, and in Avondale that often meant a factory. A major Avondale manufacturer was Florsheim Shoes, at the southeast corner of Belmont Avenue and Pulaski Road. The major Chicago shoe manufacturer built this Avondale plant in stages starting in 1924. Designed by noted Chicago architect Alfred Alschuler, it still stands as a great testament to Chicago's industrial past. It was converted to condominiums and given Chicago Landmark status in 2006. In this 1967 photograph, a Pulaski Road trolleybus heads north past Florsheim and the Maid-O-Mist factory at left (formerly St. Viator School). (Courtesy the Scalzo Collection.)

Rapid transit development transformed Avondale. By the late 1960s, construction was under way on the Kennedy Rapid Transit Extension, which would extend the present-day Blue Line north from Logan Square to Jefferson Park. A new subway was constructed under Kimball Avenue in Avondale for the line to reach the Kennedy Expressway median, and this station was built at Belmont and Kimball Avenues. The Belmont stop is seen here shortly after the line opened in 1970. (Courtesy Chicago Transit Authority.)

Above ground, construction of the cut-and-cover subway inconvenienced Avondale, much as expressway construction did a decade before. This 1968 photograph looks north from the closed Kimball Avenue toward Belmont Avenue, with an eastbound trolleybus passing above subway construction. The former I.S. Berlin Press building is at right. (Courtesy the Scalzo Collection.)

"Green limousines" were a staple of Avondale and Chicago transit for many years. The nickname referred to the green paint scheme of Chicago Transit Authority buses. Here, an eastbound Belmont Avenue bus is boarding in front of the Belmont and Kimball CTA station sometime after 1977, as the former I.S. Berlin Press building had already been replaced by the Kennedy Plaza shopping center (right). (Courtesy *Polish Daily News*.)

Ten

SHOP LOCAL

Retailing in Chicago has a storied history, but downtown department store giants like Marshall Field's and Company usually get most of the attention. Understudied but equally as important are the large, outlying shopping districts that populated Chicago, often popping up at major streetcar interchange points.

While Avondale's earliest retail districts grew around railroad stations, such as the main Avondale depot on Belmont Avenue near Kedzie Avenue, they were quickly surpassed by two major streetcar shopping districts. Eastern Avondale saw a major district emerge at the intersection of Belmont, Elston, and California Avenues in the early years of the 20th century. Western Avondale saw a similar district appear at Milwaukee, Kimball, and Diversey Avenues. These districts also spread out along their respective arterial streets.

Retail establishments located in these two districts were and are quite diverse and evolving. For instance, the district along Milwaukee Avenue has always served a large Polish clientele, with Polish delis, markets, and bookstores. The area first mainly served Americans of Polish descent, and only later did it begin to serve first-generation Poles, beginning in the 1970s. The eastern Avondale shopping district along Elston and Belmont Avenues was once a major German and Swedish district, but it quickly evolved to serve numerous other ethnic groups as the neighborhood changed throughout the 20th century.

Change is the only constant in retail developments. This is why it is fascinating to study the buildings that still remain in Avondale's shopping districts and the different establishments they have housed over the years, as well as the ways that such stores and business districts have continually tried to stay fresh and adapt to changing trends. From large department stores to small family-owned electronics retailers, major 1920s shoe stores to community banks, a wide array of businesses have existed in Avondale over the years. The following pages offer a sampling of the retail buildings and businesses that have called Avondale home since its inception.

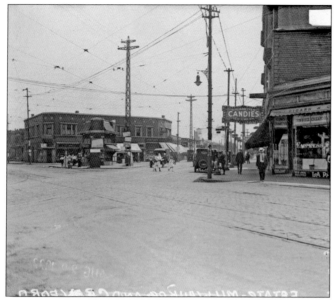

The main shopping district in eastern Avondale is the three-way intersection of Belmont, Elston, and California Avenues, a major streetcar interchange point. This photograph shows the busy intersection in 1922 looking south on Elston Avenue from Belmont Avenue. A notable landmark for many years was the small building on the traffic island (left), the Triangle Cigar Store, advertised in postcards as the "World's Smallest Cigar Store." (Photograph by *Chicago Daily News*, Inc., courtesy Chicago History Museum, DN-0074799.)

A view of the same intersection looking north on Elston Avenue in 1959 shows the tiny cigar store likely shortly before it was demolished. The large limestone building beyond it began its life as the Immel State Bank, completed in 1924 by architect Clarence Hatzfeld. This bank failed in the Great Depression, and the building was later used for multiple purposes, including the general offices of Kelling Nut Company, as seen here. Today, the building is home to Michelle's Ballroom. (Photograph by John McCarthy, courtesy Chicago History Museum, ICHi-68004.)

Many businesses in Avondale's shopping districts were family-owned affairs. This rare 1936 close-up photograph shows a soda fountain and candy store at 3185 North Elston Avenue. The owner, a Mr. Poladian, a businessman of Armenian origin, and his son Victor stand out front. A sign advertises voter registration for a primary election. (Courtesy Ralph Kruger.)

Representative of the overlooked Swedish history of Avondale is Nyberg's Bakery at 2905 West Belmont Avenue. Long since closed, the storefront is a great example of how a simple frame building was updated in the 1930s to look modern at the ground level. (Courtesy Mark Dobrzycki.)

In recent years, the Elston Avenue corridor in Avondale has become a culinary destination. Chief O'Neill's Pub & Restaurant opened at 3471 North Elston Avenue in 1999. The pub celebrates the legacy of Francis O'Neill, Chicago's chief of police from 1901 until 1905. Famously a collector of traditional Irish music, O'Neill devoted much of his retirement to publishing works that might otherwise have been lost to history. (Courtesy Mark Dobrzycki.)

The three-way intersection of Milwaukee, Kimball, and Diversey Avenues marks the southern end of the main business district of the western portion of Avondale. This view looks north on Milwaukee Avenue from Diversey Avenue in 1968. The wide variety of businesses in this district is shown here, including longtime staples Fischman Liquors and Klaus Department Store. The pop-culture claim to fame for "The Gateway to Chicago's Polish Village" is the 1992 film *Wayne's World*. The film's heroes, Wayne Campbell and Garth Algar, drive through the intersection with their friends in the infamous "Bohemian Rhapsody" scene. (Courtesy Chicago History Museum, ICHi-68001.)

The Milwaukee/Kimball/Diversey shopping district began to grow rapidly and spread north along Milwaukee Avenue after the turn of the 20th century. This c. 1910 postcard looks up Milwaukee Avenue north of Gresham Avenue. The street looks like a rutted dirt road but for the streetcar tracks. Several of these buildings are still standing. (Authors' collection.)

The Cutler Building was an Art Deco landmark at the northeast corner of Milwaukee and Diversey Avenues. It was designed by architect E.P. Steinberg and completed in 1929. Home to an A.S. Beck Shoe store for years, the building is shown here in 1948. The structure would later be demolished, and the site has been home to Fireman's Park since 1985. (Photograph by Everett H. Lang, courtesy Chicago History Museum, ICHi-68000.)

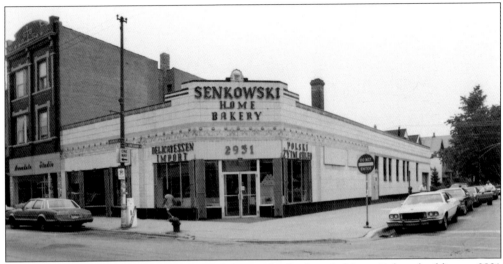

An Art Deco gem for many years in Avondale was the Senkowski Home Bakery building at 2931 North Milwaukee Avenue. With polychromatic tiles, it was very arresting for a simple one-story building. Shown here in the 1980s, the building was demolished in the early 2000s. Part of the terra-cotta facade was salvaged and installed in the interior of the Hairpin Arts Center, just down the street at Diversey and Milwaukee Avenues. (Photograph taken for the Chicago Historic Resources Survey, courtesy Commission on Chicago Landmarks.)

This photograph looks south on Milwaukee Avenue at Wolfram Street, likely in the early 1970s. The former Klaus Department Store, a longtime Avondale landmark, is visible at left. Famous Abt Electronics is at right, occupying the former Rose and later Round-Up Theater. Abt got its start at 2835 North Milwaukee Avenue in 1936, when it was founded by Jewel and Dave Abt. It moved to 2858 North Milwaukee Avenue in 1955. This location stayed open until 1977, though Abt is still doing a brisk electronics and appliance business in Glenview. (Courtesy Abt Electronics.)

This is another view of Abt Electronics looking north at the corner of Milwaukee Avenue and Wolfram Street, likely in the late 1960s. Abt demonstrated a common trend of electronics and appliance stores in the city: a dazzling display of neon. (Courtesy Abt Electronics.)

Large banks were a staple of most neighborhoods in Chicago for years, especially because Illinois law severely restricted branch banking until 1993. This is Park National Bank, at the corner of Central Park and Milwaukee Avenues, in 1957. This bank was formed and opened here in 1950, marking the end of a period without any banks along Milwaukee Avenue in Avondale following the failure of several during the Great Depression. (Photograph by Peter Fish Studios, courtesy Chicago History Museum, ICHi-68007.)

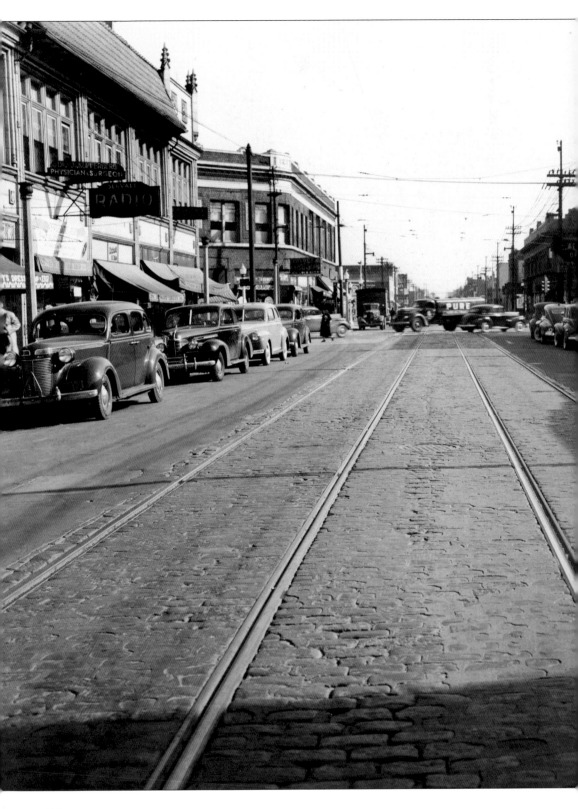

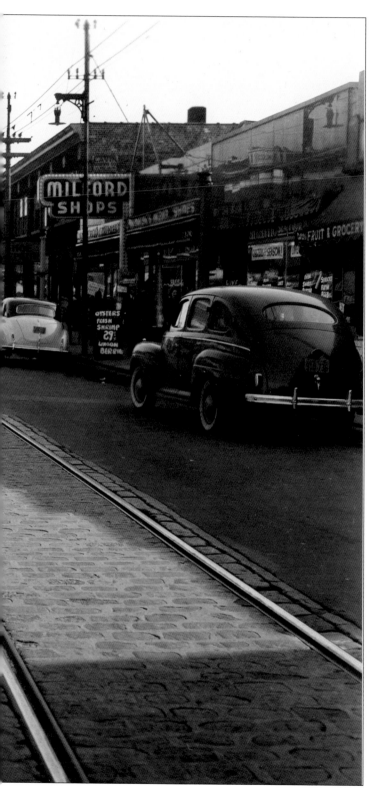

Farther north along Milwaukee Avenue, another major shopping district sprouted at the major streetcar interchange of Milwaukee Avenue, Belmont Avenue, and Crawford Avenue (later Pulaski Road). This district grew rapidly in the 1920s as the neighboring residential areas were built up. The area was sometimes advertised as Crawford Square, perhaps with an eye toward capturing some of the glamour of Logan Square to the south. This photograph looks south on Milwaukee Avenue toward Pulaski Road in 1941. Both large buildings at left have long since been demolished; the building at left beyond the intersection was the retail portion of the Milford Theatre. (Courtesy Chicago History Museum, ICHi-68006.)

These two storefronts, around the corner on Pulaski Road just north of Milwaukee Avenue, tell an interesting story of the area's retail growth and development. Tacked onto the front of residential homes, they are known as "dickey fronts," a term for a storefront that is added to a residential building once the area becomes commercial. These storefronts likely date to the late 1920s, when the intersection of Milwaukee Avenue and Pulaski Road (then Crawford Avenue) was burgeoning into a major shopping district. (Courtesy Mark Dobrzycki.)

Sometimes, homes themselves were converted into commercial uses. A longtime culinary destination in Avondale was the Ragin' Cajun Restaurant at 3048 West Diversey Avenue. Shown here in the 1980s, it inhabited an 1890 Queen Anne–style house. The restaurant is long gone, but the house still stands. (Photograph taken for the Chicago Historic Resources Survey, courtesy Commission on Chicago Landmarks.)

Animal Kingdom was a fixture for decades along Milwaukee Avenue just north of Central Park Avenue. Owner Bernie Hoffmann opened this half-pet store, half-zoo in 1944 at 3021 North Milwaukee Avenue, and it moved here to 2980 in 1965. Hoffmann passed away in 2007; the store closed in 2009, and it was torn down shortly thereafter. (Courtesy Serhii Chrucky.)

This photograph shows Bernie Hoffmann of Animal Kingdom presenting his animal-taming skills. A self-taught animal trainer, Hoffmann would rent out many of his animals for television shows and other productions. (Courtesy Steve Maciontek.)

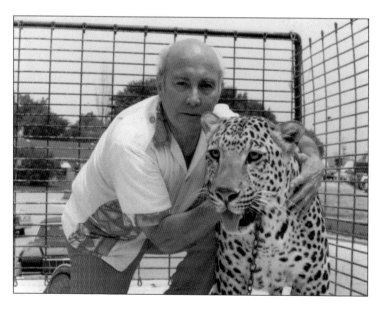

With the growing popularity of the automobile in the 1920s and 1930s, new buildings and enterprises emerged in Avondale to serve motorists. This elaborate Shell gas and service station stood at the southwest corner of Addison Street and Kimball Avenue. It is shown here sometime in the middle of the 20th century. The building no longer stands. (Courtesy Special Collections & University Archives, University of Illinois at Chicago Library, Chicago Photographic Collection, CPC_01_B_0203_016.)

Funeral homes are an unappreciated aspect of Chicago's built environment. Avondale had many, often near Catholic churches on residential streets. However, some were located on commercial streets, including Theis-Gorski Sveta Gora Funeral Home at 3517 North Pulaski Road, which now specializes in serving Chicago's Serbian American community. (Courtesy Mark Dobrzycki.)

Roman's Religious Goods was located at 2992 North Milwaukee Avenue. This c. 1980 photograph shows the venture's humble beginnings in this storefront. Today Roman, Inc. is among the largest privately owned and operated firms in the inspirational goods industry, the producer and exclusive distributor of more than 8,000 gifts and fixtures. (Courtesy Ron Jedlinski.)

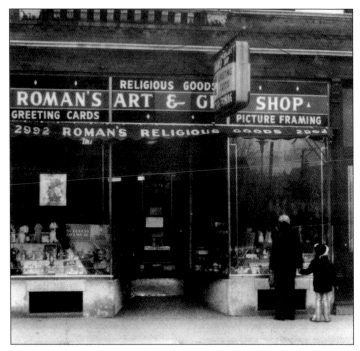

Augustyn's, at 3646 West Belmont Avenue, reflects the early Polish heritage of the western portion of Avondale. This postcard likely dates from before 1920 and shows the white tile building that still exists to this day, though the tile work is now hidden under siding. (Authors' collection.)

Just to the west of Augustyn's, at 3648 West Belmont Avenue, is a twin building but with its glazed white tile work still intact. It was most recently home to Stanley's Sausages, a longtime favorite in the Polish Village. The establishment has since closed. (Courtesy Dan Pogorzelski.)

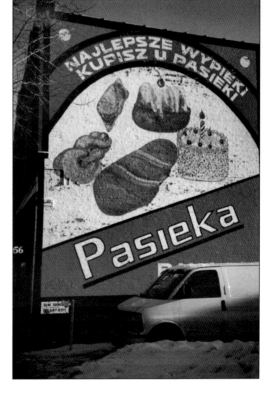

One of the retail landmarks of the Polish Village for many years was Pasieka Bakery at 3056 North Milwaukee Avenue. Pasieka's baked goods were known far and wide, and its curved glass storefront was a great example of 1930s storefront modernizations spurred by policies of the New Deal era. Unfortunately, Pasieka suffered a major fire in 2011, and the building was later demolished. (Courtesy Dan Pogorzelski.)

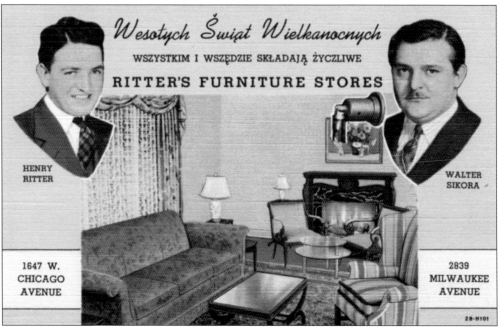

This 1942 postcard advertises Ritter's Furniture Stores, with a location at 2839 North Milwaukee Avenue. The building would later become home to Klaus Department Store. The postcard is in English and Polish, a reflection of the vibrant Polish community in Avondale. (Courtesy Lake County [IL] Discovery Museum, Curt Teich Postcard Archives.)

Jackowo (pronounced *yats-ko-vo*), the community centered around St. Hyacinth Basilica, has long been the leading "Polish patch" making up Osada Polska, the Polish translation of "Polish Village." In Poland, Jackowo is perceived to be the primary Polish neighborhood of Chicago. Until the recent installation of an automated system, CTA bus drivers often announced "yats-ko-vo" at the Central Park Avenue stop along the Milwaukee Avenue bus route. (Courtesy Dan Pogorzelski.)

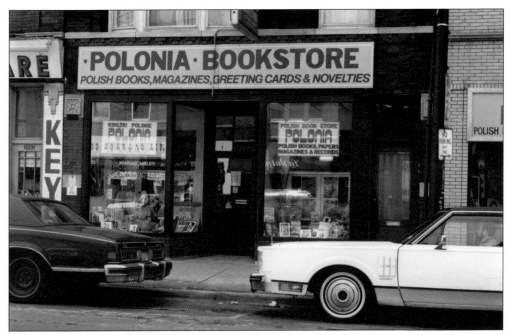

This 1980s photograph shows Polonia Bookstore at 2886 North Milwaukee Avenue. It has served a vital role as a cultural hub for Polish literati, such as Nobel laureate Czesław Miłosz and Polish film writer Tadeusz Konwicki. Still in business, Polonia has moved north along Milwaukee Avenue to Jefferson Park. (Courtesy Polonia Bookstore.)

In the era before MP3s and CDs, Avondale Discount Records was a destination in Chicago's Polish Village specializing in the sounds of Eastern European jazz and rock music. The store, at 2888 North Milwaukee Avenue, is now home to an artist studio. (Courtesy Dan Pogorzelski.)

As the port of entry for most Poles coming into the Chicago Metropolitan Area, the Polish patch of Jackowo was where Polish immigrants, refugees, and transients learned the American way of life. A case in point is this 1980s photograph of the display window at Staropolska Restaurant, at 3030 North Milwaukee Avenue, welcoming clients for Thanksgiving and encouraging them to go native and have some turkey. (Courtesy *Polish Daily News*.)

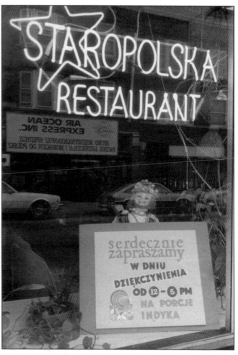

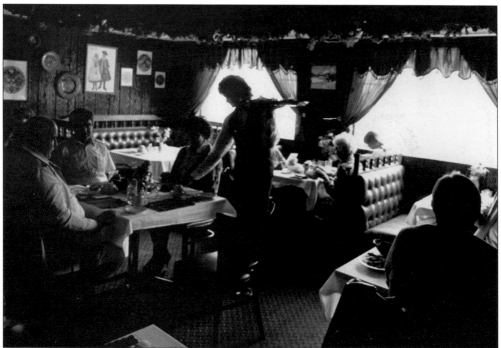

Słowik Hall, shown here in the 1980s, was located on the west side of Milwaukee Avenue just north of Belmont Avenue in the building that until recently housed the Congress Restaurant. Not just home to Polish food and dancing, it also served as a communal space for Polish events and a place for organizations to meet, socialize, and cavort with the occasional politico currying their favor. (Courtesy *Polish Daily News*.)

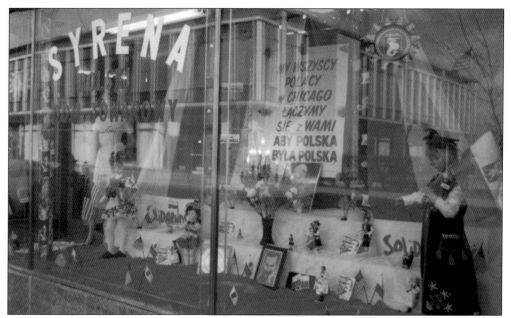

Department stores were once a staple of every Chicago neighborhood, including in ethnic enclaves. Syrena, shown here in the 1980s at 3004 North Milwaukee Avenue in Chicago's Polish Village, is still open as of this writing. The display window is bedecked in the patriotic colors of Poland in support of the Solidarity trade union, the popular Polish anti-Communist movement that would eventually triumph in Eastern Europe. (Courtesy Jerzy "George" Skwarek.)

The Milwaukee Avenue shopping district has changed and evolved numerous times throughout the years. For instance, Walter's Men's Shop at 2971–2973 North Milwaukee Avenue would later be displaced by the modernist Avondale Federal Savings Bank sometime after this 1950 postcard was issued. (Courtesy Lake County [IL] Discovery Museum, Curt Teich Postcard Archives.)

Neighborhood merchants and chambers of commerce are always looking for new ways to improve the appearance of their business districts. In 1954, "The New Milwaukee Look" was completed, which involved street widening, resurfacing, and the installation of new streetlights along Milwaukee Avenue between Belmont and Fullerton Avenues. It culminated in a parade on November 17 of that year. This 1954 photograph looks north along Milwaukee Avenue, just past Central Park Avenue, with the future home of Animal Kingdom visible at left. (Authors' collection.)

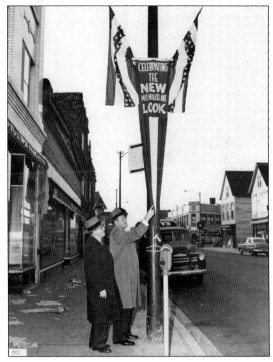

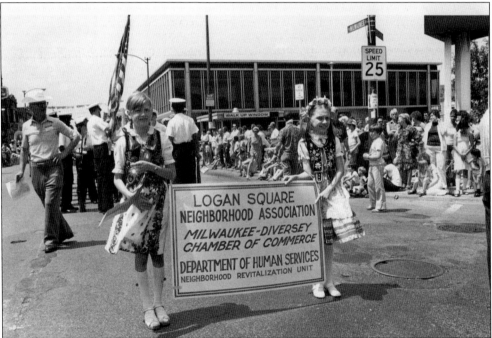

Parades were once a common sight along Milwaukee Avenue. They were usually sponsored by the local business association in an attempt to draw attention to a business district (in this case, the Milwaukee-Diversey Chamber). Shown here is a parade in the late 1970s or early 1980s. The view is looking north at Central Park and Milwaukee Avenues. The long-gone modernist Avondale Federal Savings Bank is at right. (Courtesy Steve Maciontek.)

DISCOVER THOUSANDS OF LOCAL HISTORY BOOKS FEATURING MILLIONS OF VINTAGE IMAGES

Arcadia Publishing, the leading local history publisher in the United States, is committed to making history accessible and meaningful through publishing books that celebrate and preserve the heritage of America's people and places.

Find more books like this at
www.arcadiapublishing.com

Search for your hometown history, your old stomping grounds, and even your favorite sports team.